SEPT. 18-85 K. Haring

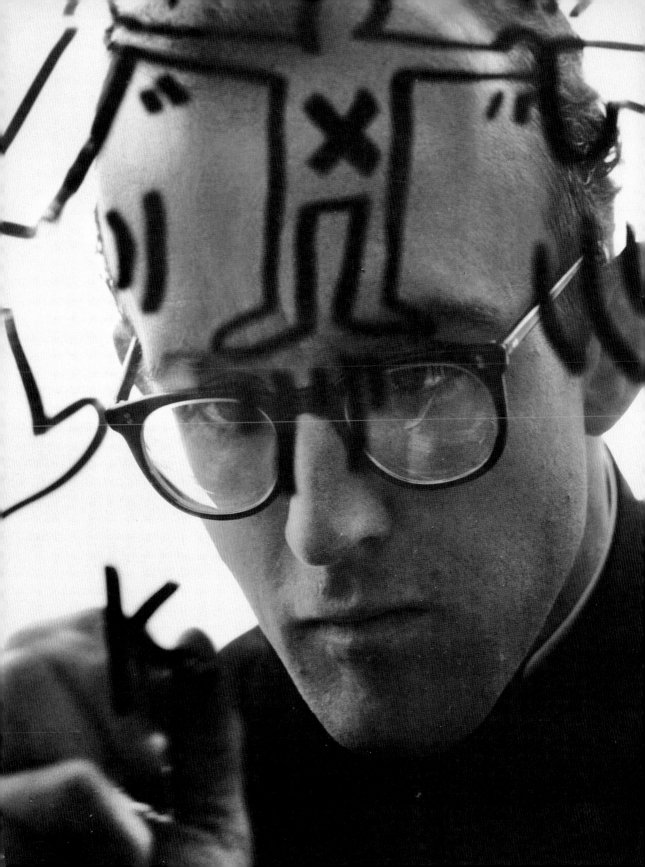

Alexandra Kolossa

KEITH HARING

1958–1990

A life for art

TASCHEN

KÖLN LONDON LOS ANGELES MADRID PARIS TOKYO

COVER:
Untitled, 1982
Vinyl ink on vinyl tarpaulin, 183 x 183 cm
Private collection

BACK COVER:
Keith Haring painting his office at 611 Broadway, New York, 1984

ILLUSTRATION PAGE 1:
Untitled, 1985
Graphite on note paper, 15 x 14 cm
New York, The Estate of Keith Haring

ILLUSTRATION PAGE 2:
Haring signs one of his drawings on glass in Tokyo, 1988

To stay informed about upcoming TASCHEN titles,
please request our magazine at www.taschen.com
or write to TASCHEN America, 6671 Sunset Boulevard, Suite 1508,
USA–Los Angeles, CA 90028, Fax: +1-323-463.4442.
We will be happy to send you a free copy of our magazine
which is filled with information about all of our books.

© 2004 TASCHEN GmbH
Hohenzollernring 53, D–50672 Köln
www.taschen.com
© 2004 The Estate of Keith Haring
Project management: Petra Lamers-Schütze, Cologne
Coordination: Christine Fellhauer, Cologne
English translation: Michael Scuffil, Leverkusen
Production: Ute Wachendorf, Cologne
Layout: Claudia Frey, Cologne

The author would like to thank Julia for her dedication and trust, and Georg for
his critical comments.

Printed in Singapore
ISBN 3–8228–3145-x

Contents

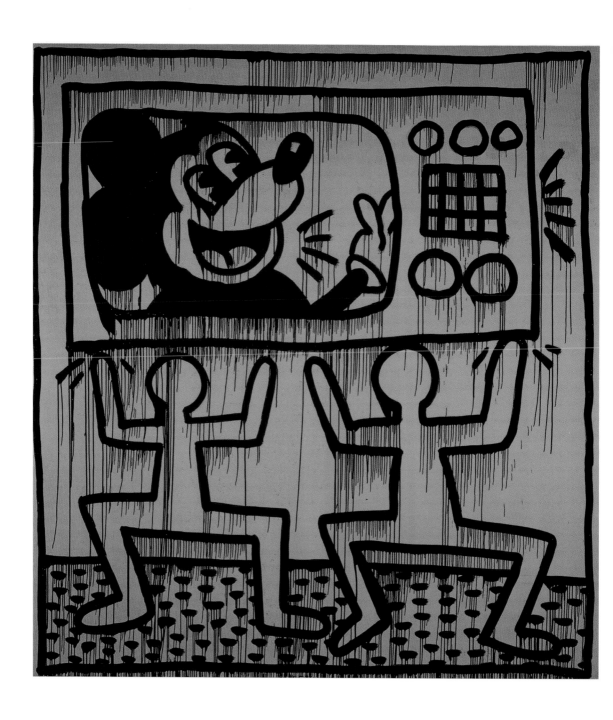

Art is life, life is art

In the early hours of the morning of February 16, 1990, Keith Haring died of AIDS at the age of just 31. He left behind an enormous oeuvre of drawings and paintings, murals and sculptures, as well as countless printed T-shirts and posters: a comprehensive legacy produced in the course of ten years of creativity by an artist who left no "late" works. In spite of his youth, Haring at the time of his death was already a celebrated artist, established in the eyes of his fellow-artists, accepted by the critics and loved by children. During his short life he became an American export hit, achieving fame and commercial success. Like almost no other artist, he understood how to combine his personality and his art into a single entity. His artistic trademark is the line, formally reduced to its essentials, which spreads out in many ways within the restricted area of the picture and takes proper account of its proportions. And it is always a continuous line, guided by the principle of chance, becoming an outline, then a figure and finally a symbol. Mostly, the beholder needs just a brief glance in order to register what is to be seen and understood in his works. The particular fascination of Haring's art, however, lies in his ability to combine this strongly graphic style with a great deal of imagination. His figures and forms are subject to continuous transformations and new creations, providing ongoing proof of his qualities as a draftsman, painter and sculptor. Within his oeuvre, we witness a steady stylistic evolution. His constant search for new challenges is accompanied by experimentation with changing surfaces on which to paint. No matter whether he chooses to paint on walls, items of clothing, automobiles or airships and most of all on paper, canvas, untreated cotton or vinyl, Haring's hallmark is perfection of execution. Neither for his formally planned projects nor for his spontaneous mural designs are his lines based on sketches or studies. We can discern no errors or corrections, no asymmetries of proportion. Spontaneity and assurance are the outstanding attributes of his work.

Thousands wear his T-shirts; millions recognize his style. This was true when he died, and it is still true today. The "getting accustomed to his art" phase was brief. For nothing that Haring painted was unknown to the public. He copied and integrated what he saw around him. Equipped with a sure instinct for the sensitive issues of his time, Haring became a voyeur of American society and acted as a medium that every day absorbed and processed inspirations before disseminating them via artistic statements that he quite consciously geared to the spirit of

Haring took every opportunity to tag in public spaces, even on discarded doors.
New York, 1982

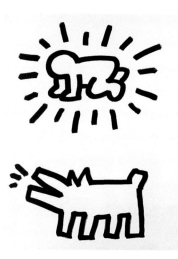

Drawings from the artist's sketchbook, 1982
Black felt-tip pen on paper, 36 x 43 cm
New York, The Estate of Keith Haring

Keith Haring and LA II
Untitled, 1984
Black enamel and black felt-tip pen on
baked enamel sign, 112 x 112 cm
Private collection

his age. For Haring was not just a producer, but also the product of a particular generation, of a particular way of life. Having grown up himself with comics and cartoons, he enjoyed the best preconditions for developing a fine sense of what was "deep-down" American. With Spartan artistic means, he succeeded in pointing to such general aspects as the exposed position of the medium of television (ill. p. 6).

Keith Haring was not self-taught. He was trained as an artist, he thought of himself as an artist, and it was as an artist that he profited from the dawning media age, from the scandalous reputation of the New York club and party scene, and from the needs of a consumer society. Right from the start of his career he gave the artistic mainstream a wide berth, breaking with the cultural conventions of his age by contravening the rules of the art business, even at the risk of being ignored. Instead of working in the shelter of a gallery, Haring seized the opportunities offered him by public spaces. These included the empty advertising spaces on the walls of New York subway stations, and an early acquaintance with the burgeoning graffiti scene. With his kind of art, Keith Haring quickly became the youthful hero of a whole generation, symbolizing and personifying for many the America of the 1980s. His pictures and signs became the messages of this generation, fixtures of the culture that they symbolized. Without, in the process, throwing out its profound content, Keith Haring knew how to combine his art with the garish manifestations of mass advertising. A literal implementation of his working method shows a Coca-Cola advertising sign that serves him as a painting surface (ill. p. 8 bottom).

It is still the early work, now stylized as iconic, with which Haring's name is primarily associated: the crawling baby in a radiant halo, the barking dog with an angular muzzle (ill. p. 8 top), or faceless figures exposed to absurd situations (ill. p. 9). This reduction to his justifiably famous icons does not, however, in any way do justice to his artistic talent. His work is like his life: varied, headlong and purposeful. Within his easily accessible pictorial language, Haring experimented at the formal level with a whole spectrum of stylistic possibilities. These range from figures reduced to just a few strokes to works covering the whole of the surface in question. From the point of view of content, he drew on a repertoire, which, at its core, speaks of love and happiness, joy and sex, but also of violence, abuse and oppression.

Keith Haring always believed in the power and ability of art to change the world, in the sense that he thought it could exercise a positive influence on people. He understood himself as an intermediary between the world of art and the streets of New York, (and the street kids with whom he never lost contact). It was from this very personal environment that he drew his motifs, developing from them a pictorial theme that cannot be disentangled from his own biography. This is why the value of his pictures cannot be reduced to their mere market value. Their actual value consists in the testimony to the age that is reflected in them. His pictures should be seen as painted contemporary history, some of them indeed as painted current affairs, directly reflecting a particular event. In this way, he created an iconography of our age, insignia of a modern civilization, which provides information on the people of the late 20th century. If we look at his art in this realization of its close connection with his life, we will see why he painted the things he painted, and why he painted the way he painted.

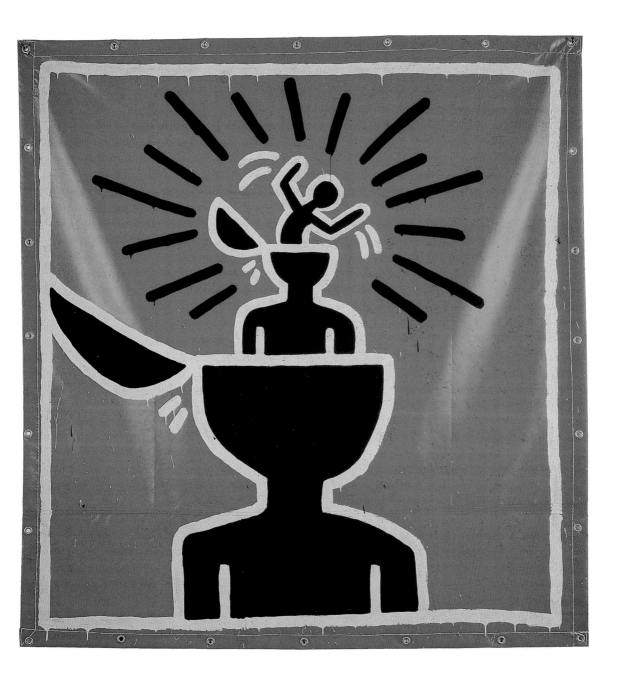

Untitled, 1982
Vinyl ink on vinyl tarpaulin, 183 x 183 cm
Private collection

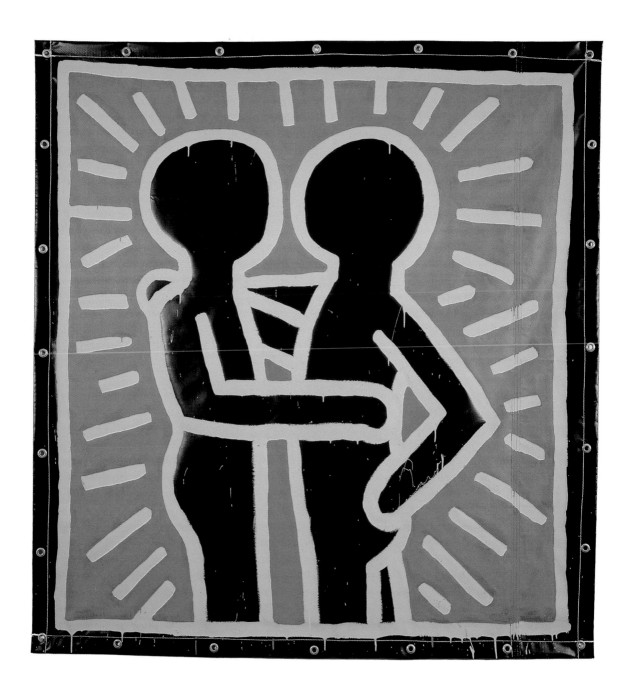

How the baby learned to walk

Keith Haring grew up in Kutztown, Pennsylvania near his birthplace, Reading, the eldest of four children and the only boy, and at an early stage demonstrated artistic ambitions that were recognized and encouraged by his father, Allen. Their joint drawing sessions were Keith's earliest memory of artistic activity. To his biographer John Gruen, to whom we owe honest and frank insights into the artist's private life, he reminisced: "My Dad made cartoon characters for me, and they were similar to the way I started to draw—with one line and a cartoon outline." The characters in question were those in Walt Disney, Dr. Seuss and other heroes of animated TV cartoons. It was these in particular that awakened his enthusiasm and continued to impress him on a lasting basis. Haring had a sheltered, very disciplined and in some respects conservative childhood. His father Allen was a department head at the electronics company AT&T, while his mother Joan ran the household. It appeared to be, in other words, the perfect American family, but one whose narrow limits the boy soon put to the test, and frequently overstepped. Shielded at home from the cultural revolution of the 1960s, his only source of information was the occasional visit to his grandmother, for there he could read, with alacrity, such magazines as *Look* and *Life*, which were later to enlighten him on the prevailing political situation. The most important information medium however continued to be television. This was how he found out about the most important events of the time, events that moved him deeply, from the Vietnam war to the moon landing.

As a teenager, he openly demonstrated his independence and will power, experimenting with drugs and alcohol. Haring's predilection for drawing remained with him throughout his youth. In a drawing that he made as a 16-year-old, he executed a dense rendering of the things that surrounded and shaped him, from the various rock-group labels to hidden references to comic figures (ill. p. 13 top). According to Haring himself, one important experience for his artistic career was an excursion to the Hirshhorn Museum in Washington D.C., where, for the first time, he saw works by Andy Warhol, a Marilyn series. This encounter ushered in the internal decision-making process that led to his taking up art as a career.

After graduating from high school in the summer of 1976, Haring enrolled at the Ivy School of Professional Art in Pittsburgh. On the advice of his parents, he started by taking the course in advertising graphics. He soon realized, however,

Invitation card for exhibition at the
Arts & Crafts Center, Pittsburgh, PA, 1978
New York, The Estate of Keith Haring

ILLUSTRATION PAGE 10:
Untitled, 1982
Vinyl ink on vinyl tarpaulin, 183 x 183 cm
Private collection

11

Untitled, 1978
Black ink on paper, 290 x 271 cm
New York, The Estate of Keith Haring

"One of the things I have been most interested in is the role of chance in situations—letting things happen by themselves. My drawings are never preplanned. I never sketch a plan for a drawing, even for huge wall murals. My early drawings, which were always abstract, were filled with references to images, but never had specific images. They are more like automatic writing or gestural abstraction."
KEITH HARING, 1984

that he did not want to become a commercial graphic artist. After just two semesters, he dropped out of this college and kept his head above water by doing various odd jobs. One of these, as an assistant-cook at a chemical company, gave him the chance to stage his first exhibition in the cafeteria, where he put his drawings on public display for the first time. Although Haring had not matriculated at the university, he continued to make use of its facilities, attending seminars and using the library. His personal interest in art led him to books on Jean Dubuffet, Stuart Davis, Jackson Pollock, Paul Klee, Alfonso Ossorio and Mark Tobey. As a result, he found himself confronted with an understanding of art, which, as he said, made a very profound impression on him. But of even greater importance to his further artistic development was a retrospective of the works of Pierre Alechinsky that took place at the Museum of Art, Carnegie Institute, in Pittsburgh in 1977. This encounter gave him the self-confidence to pursue his own artistic endeavors. From then on, he experimented with sizeable formats and other graphic techniques. Just one year later, in July 1978, he got the chance to display the results of these experiments at a small exhibition of drawings and paintings at the Pittsburgh Arts & Crafts Center, his first artistic success (ill. p. 11). From an early stage, Haring assigned a major role to the beholder in connection with his art: "I am interested in making art to be experienced and explored by as many individuals as possible with as many different individual ideas about the given piece with no final meaning attached. The viewer creates the reality, the meaning, the conception of the piece. I am merely a middleman trying to bring ideas together." The geographical and creative limitations of Pittsburgh resulted in Haring making the decision to leave his familiar surroundings and move to New

York in his search for like-minded artists and new challenges. At that time, he was also becoming increasingly aware of his own homosexuality, which he openly acknowledged.

Having arrived in New York, he enrolled at the School of Visual Arts (SVA), where he attended courses in drawing, painting, sculpture and the history of art. As a student he extended his experimental phase, developing videos, installations and collages inspired by Jenny Holzer's *Truisms* and the techniques of William S. Burroughs and Brion Gysin. Alongside an intensive interest in language, he also intensified his passion for drawing. Early works dating from this period already provide some indication of his predilection for the line, whether as a hieroglyph-like symbol, or in the form of austerely geometric structuring (ill. p. 12). In general, his professors acknowledged a purposeful and decisive approach on his part, coupled with an enormous creative urge. Haring discovered that other fellow-students at SVA shared his energy and enthusiasm for art. He became close friends with one of them, Kenny Scharf, with whom he shared an apartment for a time, and made the acquaintance of Jean-Michel Basquiat, whose tag had already come to Haring's attention. Haring produced ceaselessly, incorporating all his impressions into his works. By day he attended the university, exploiting its closeness to galleries and museums, and by night he frequented the bars, clubs or bath-houses of the gay scene.

Untitled, 1974
Felt-tip pen on paper, 41 x 69 cm
New York, The Estate of Keith Haring

Untitled, 1978
Sumi ink on paper, 51 x 66 cm
New York, The Estate of Keith Haring

Untitled, 1979
Chalk on paper, 136 x 185 cm
Private collection
Courtesy Deitch Projects, New York

A drawing that accords major importance to the theme of sexuality also evidences the close connection between Haring's art and private life. This work, dating from 1979, when he was still a student, is dedicated to Kenny Scharf (ill. p. 15 middle). The picture is drawn on a sheet of graph paper, whose right-hand side is strewn with countless little identical symbols. Closer inspection reveals each of these three-arched symbols to be the outline of a stylized penis, the glans emphasized with a red pencil. The symbols are placed cheek-by-jowl, but without touching or interfering with each other, and adjusted to the existing edges of the paper. In a similar work, dating from the same year, he takes up the same theme once more, this time on a large scale on black paper (ill. p. 14). The collection of little penises, executed in fine white chalk outlines, comes across, in its compressed evenness, like a decorative pattern.

Alongside art, club life was a further form of energy shared by many artists during the 1980s. Institutions like the Mudd Club, Club 57 or the Paradise Garage discotheque were among the venues of the alternative scene that enjoyed a certain social cachet. Not just musical events took place here, but also exhibitions, readings and live performances, in which Haring took part. These clubs were popular rendezvous for artists, musicians and actors. Many a career began in this way. Haring, who in the course of time became a fixture on New York's alternative art and club scene, was at first most often to be encountered at Club 57. This

"hole in the wall" was overtaken by the clique of whom he was the central figure, and was located in the basement of a Polish church. For many years he was active here as the organizer and curator of unusual exhibitions, which often lasted no longer than a single night. Driven by the constant urge to give his artistic activity a purpose, in 1980 Keith Haring created the first of his works to be aimed at a broader public. The first of these actions was limited to his own neighborhood, the East Village, which was the preferred haunt of young artists. With the aid of a stencil, he sprayed the words *Clones Go Home* on the walls and sidewalks along the boundary between West and East Village (ill. p. 15 bottom). The intention was to scare away the—in his opinion—nouveau riche newcomers to the adjacent neighborhood. It was in particular the uniform external appearance of these predominantly gay yuppies—defined by their moustaches, heavy musculature and back-pocket, color-coded bandanas that made them into clones for him: "We felt the East Village was a different kind of community which we didn't want too cleaned up in the way of the West Village. Even though the West Village had a large gay population, they weren't quite our type of gays."

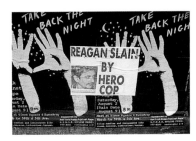

For another notorious campaign, he produced photocopies with headlines whose appearance was deceptively (and intentionally) similar to those on the front page of the *New York Post* (ill. p. 15 top). Using old headlines, he compiled new and highly provocative messages such as "Reagan Slain by Hero Cop", "Pope Killed for Freed Hostage" or "Mob Flees at Pope Rally". Posted over the whole of the East Village, these text collages aroused considerable attention and provided for no little confusion.

After Keith Haring had worked in other media for a while, he felt the need to draw once more, and to create more permanent works on paper. Thus in the summer of 1980 he directed his attention chiefly to drawing. Equipped with a roll of paper and Sumi ink, he created his first serial drawings, which already evince the stylistic characteristics that are the hallmark of his total oeuvre. One of these early drawings demonstrates, like an educational poster, the main pillars of life (ill. p. 16). We see, reduced to pictograms, a nuclear reactor, a pyramid and

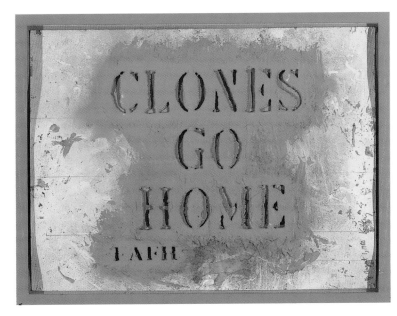

ILLUSTRATION TOP:
Reagan Slain by Hero Cop, 1980
Newspaper collage, photocopy, 22 x 28 cm
New York, The Estate of Keith Haring

Collage of transposed "New York Post" headlines, using original material, pasted by Haring on buildings and construction sites in New York City

ILLUSTRATION ABOVE:
Untitled, 1979
Graphite on paper, 24 x 33 cm
New York, Kenny Scharf Collection

ILLUSTRATION LEFT:
Clones Go Home, 1980
Powdered pigment and graphite on paper stencil, 51 x 66 cm
New York, The Estate of Keith Haring
His *Clones Go Home* street art campaign was one of the few in which Haring used spray paint.

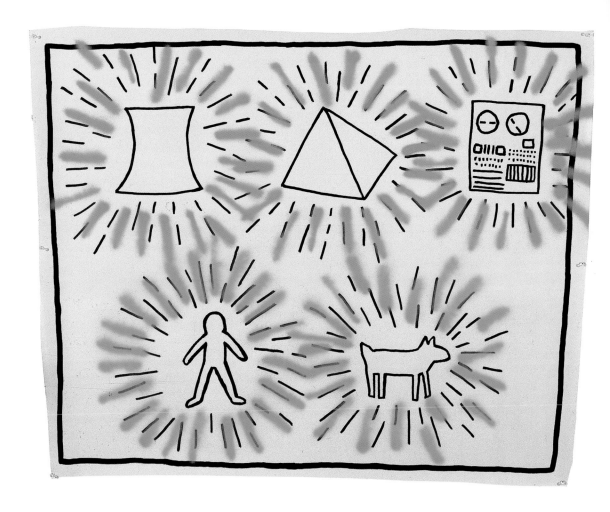

Untitled, 1980
Acrylic, spray paint and Sumi ink on paper,
113 x 138 cm
New York, The Estate of Keith Haring
Courtesy Deitch Projects, New York

a computer. These symbols stand for the present, the past and the future. Subordinated to these are the categories of man and beast, symbolized here by his dog. The individual symbols are surrounded by radiant haloes, which are further emphasized by spray-paint. Haring thus introduced into his works "radiant energy"; the exact origin and purpose of which is further explained by other drawings of the period (ill. p. 17). Originally, the ray of energy emanated from a UFO, charging the persons and objects in its path with a special strength. In the first drawing, the rays of the UFO hit a pregnant woman, causing her to give birth, and also irradiate the baby, which is received by a cheering crowd. Everything touched by the rays becomes radiant, and from then on characterized by a radiant halo. The drawings, each of which is subdivided into individual picture fields which can, taken together, be read as a story, take up the motif of the flying saucer, tell of wandering figures, babies and dogs, of sex between people and animals, but also of the misuse of that radiant strength—misuse which is immediately punished. This radiant halo, an altogether positive characteristic, should be interpreted as a symbol of particular strength and energy, and not be confused with any kind of radioactivity. For Haring, this image development was pure chance:

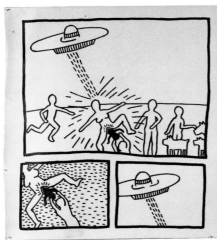
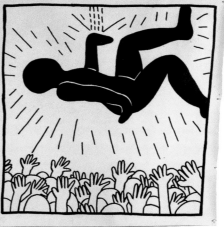
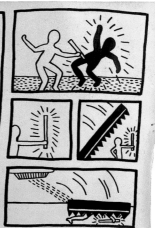
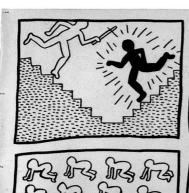
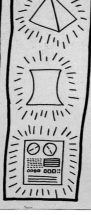
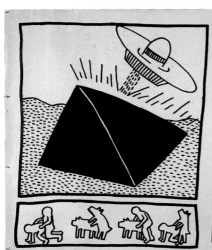
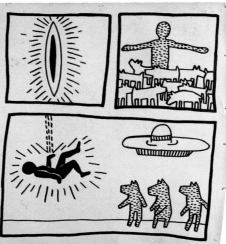

Keith Haring in the New York subway, 1983

"In all my work there is some degree of content that is more obvious, communicating a specific or a general idea that people will get. But a lot of times the content of the work is ambiguous enough that it can be interpreted by whoever. That was one of the essential things that made the subway drawings powerful. They weren't exactly telling you what they meant."
KEITH HARING, 1990

"I have no idea why it turned out like that. It certainly wasn't a conscious thing. But after these initial images, everything fell into place, and after that, everything else made sense. Right away, I thought of showing these pieces at Club 57, and it turned out to be a one-night exhibition." In these few, at first somewhat clumsy-looking pictorial elements, we already see the beginnings of the iconic language which was to be associated with the name of Keith Haring ever after— a language consisting of a concrete visual communication through non-verbal symbols. Haring consciously sought in his works to find a standpoint from which to combat abstract painting, which, in his view, had nothing to say to the world. He was concerned with communication more than with anything else.

18

Firmly rooted in the alternative sub-culture and already enjoying good contacts with the New York art scene, Haring decided in the fall of 1980 not to enroll for the winter semester at SVA. He believed that the people there had nothing more to teach him. By making this decision, he voluntarily denied himself the chance of a university degree, which was eventually awarded him posthumously in 2000. He began to earn his living with odd jobs once more, and continued to organize numerous group exhibitions at Club 57 and the Mudd Club. The exhibitions of his own works, in the Westbeth Painters Space, Club 57, the Hal Bromm Gallery and in P. S. 122, were usually designed as space-consuming installations. The latter resulted in the first review of his work in the *SoHo Weekly News*.

In the winter of 1980, Haring took to the streets again. Unmotivated by traditional art institutions, he once more chose the urban environment for his artistic activity. Equipped with nothing more than a marker, he set about altering advertising posters, also leaving his own tags in the manner of graffiti artists. These tags concealed abbreviations that imaginatively reproduce the artist's signature, thus allowing him to be identified. As a young man from Pittsburgh, Haring was fascinated by the first graffiti he encountered on the New York streetscape. He admired the virtuoso talent of these artists in their handling of the spray-can and sympathized with their illegal actions, in which they were acting beyond all art and commerce, in public, and visible to all and sundry. Haring reacted to the existing tags with an iconic language typical of him. For his personal signature, he chose at first an animal that, subsequently, increasingly came to resemble a dog, a barking dog with an angular muzzle. In addition, he designed the figure of a human on all fours, which developed into the prototype of the crawling baby. "The reason that the 'baby' has become my logo or signature is that it is the purest and most positive experience of human existence." Sometimes drawn in series, sometimes juxtaposed, in various combinations with different meanings each time, he placed his tags in precisely those places where other graffiti artists had already left theirs (ill. p. 19 bottom). By marking out these places as his own patch, he was not just seeking contact with the graffiti artists, but also recognition from them.

Not by Keith Haring, n.d.
Black ink and silver felt-tip pen, 102 x 74 cm
New York, The Estate of Keith Haring

Tags by Basquiat and Haring, ca. 1981

Haring's crawling babies developed as his graffiti tag. The three-pointed crown was the tag of Jean-Michel Basquiat.

Although Haring never really belonged to the New York graffiti scene, the myth is still associated with him even today. Instead of working with spray-paint himself, what he did, rather, was to draw inspiration from the communicative power of graffiti. He exploited the approach for his own ends, namely, to broaden the traditional access routes to art and culture. As time went by, Haring began to discover the enormous potential of his inimitable originality and to exploit it more intensively. The streetscape rapidly succumbed to his icons, and they in turn encouraged imitators. Haring demonstrated his sense of humor by correcting obvious plagiarisms himself (ill. p. 19 top).

At the same time, in June 1980, Haring was invited to take part in the Times Square Show. It was the first exhibition designed to present the whole spectrum of "underground art", including graffiti art. The event was taken note of even within establishment art circles. In an empty building, a total of a hundred artists, expounding on a whole variety of trends and concepts, exhibited their works, among them Kenny Scharf and Jean-Michel Basquiat. For the first time, Haring was now exhibiting himself and his work in a context that allowed for direct comparison with other artists. This show also provided an opportunity for him to meet the best-known graffiti artists of the time, including Lee Quinones, Fab Five Freddy and Futura 2000. The result was a real friendship, accompanied by joint artistic enterprises, the black marker never out of reach. Haring's enthusiasm for graffiti art led him to organize an exhibition on this theme at the Mudd Club in the spring of 1981; it was a great success.

For another form of his public art in the following years Keith Haring chose, maybe by chance, maybe on purpose, the New York subway to be his exhibition venue. Driven spontaneously by his curiosity and equipped with an intuitive sense of the right location, his attention was drawn to the vacant advertising panels in the subway stations—unused and pasted over with sheets of black paper. To his biographer John Gruen he described this moment of discovery as

Subway drawing next to circus poster, 1983
Chalk on paper

Haring used vacant advertising space in the New York subway stations to communicate his own messages, often in dialogue with the adjoining advertisement.

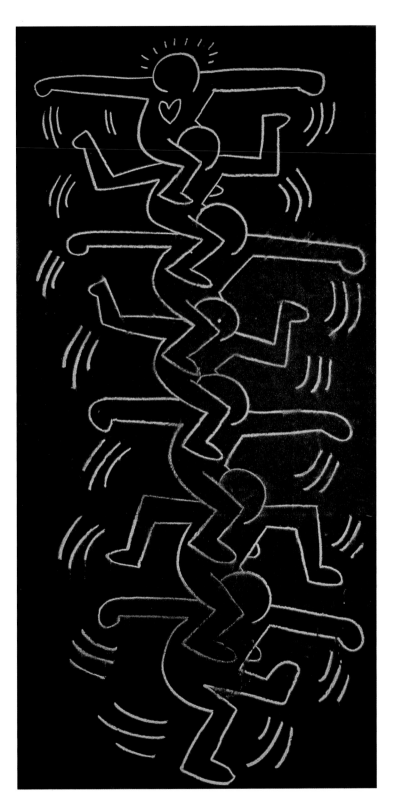

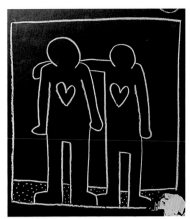

Subway drawings, 1985
Chalk on paper

"I see things in the street that are not intended
to be art, but for me they're aesthetically
interesting, so it's art to me. I see painted trucks
or painted old, decaying billboards or some-
thing that, to me, provide information and
inspiration and some kind of visual, whatever.
Something clicks in your head."
KEITH HARING, 1988

21

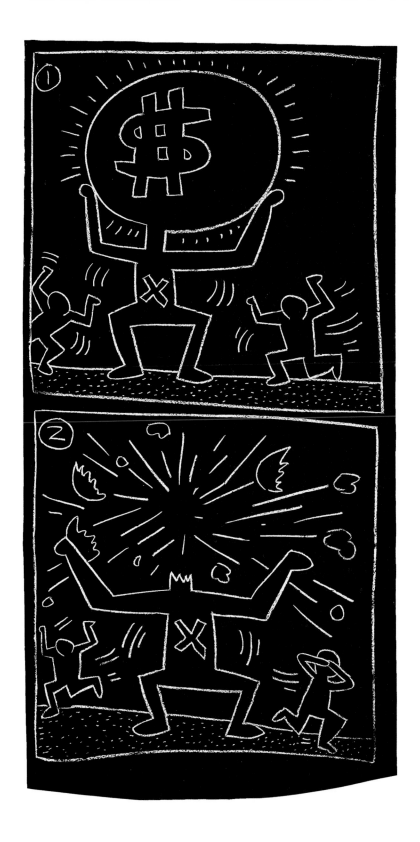

pointing the way ahead: "As I kept seeing these black subway panels everywhere, I realized what I had discovered. Suddenly, everything fell into place. All that I had been watching and observing throughout the two years I was in New York made perfect sense. Now I found a way of participating with graffiti artists without really emulating them, because I didn't want to draw on the trains. Actually, my drawing on those black panels made me more vulnerable to being caught by the cops—so there was an element of danger." And indeed, the cops frequently caught him red-handed. He received more than a hundred tickets during his active period. In one case, he was even arrested and led away by the police.

Instead of a marker, Haring now worked with chalk, an extremely sensitive material, which, however, accorded with his wish to work uninterrupted and quickly. "To draw in chalk on this soft black paper, that was a totally new experience for me. It was a continuous line; you didn't need any interruptions to dip your brush or whatever in paint. It was a constant line, a graphically really very strong line, and you were working under a time limit. You had to work as fast as you could. And you couldn't correct. Mistakes couldn't happen, so to speak." The subway was, as Haring put it, his "laboratory", in which he was able to perform countless experiments with, and variations on, his clear lines (ill. pp. 18–23). His procedure was always the same. First he drew a frame, and then, in just a few

ILLUSTRATION PAGE 22:
Untitled, 1984
Chalk on paper, 203 x 107 cm
Private collection

Untitled, 1985
Chalk on paper mounted on board, 117 x 153 cm
New York, The Estate of Keith Haring

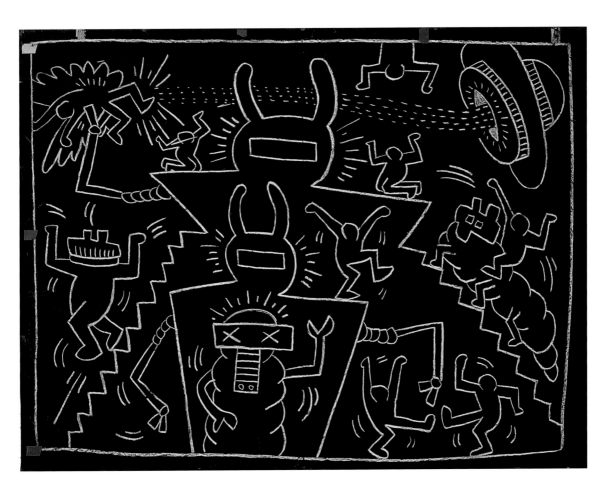

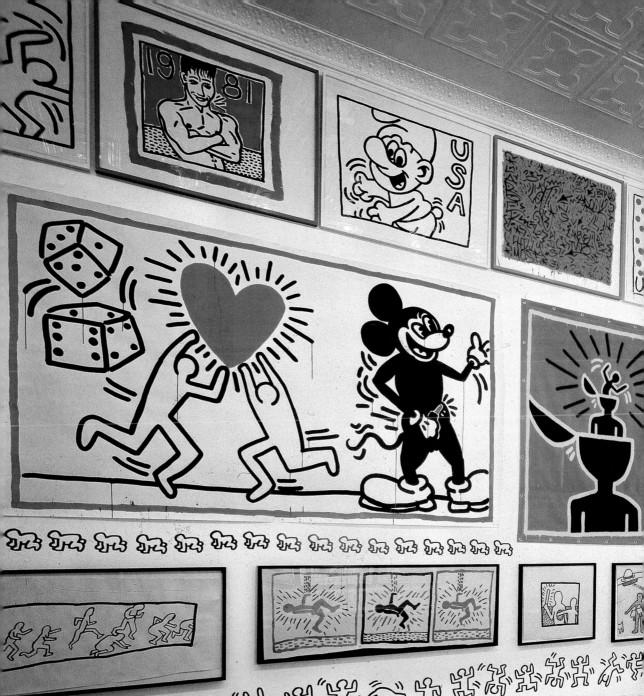

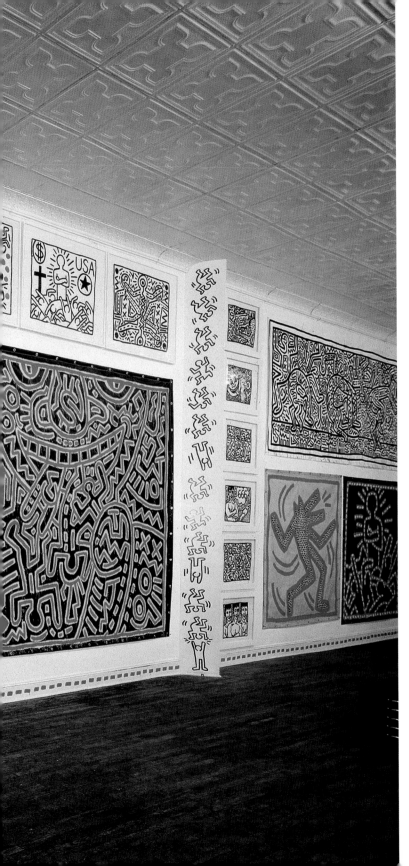

"Art lives through the imaginations of the people who are seeing it. Without that contact, there is no art. I have made myself a role as an image—maker of the twentieth century and I daily try to understand the responsibilities and implications of that position. It has become increasingly clear to me that art is not an elitist activity reserved for the appreciation of a few, but for everyone, and that is the end toward which I will continue to work."
KEITH HARING, 1984

"Keith Haring" exhibition at the Tony Shafrazi Gallery, New York, October 1982

25

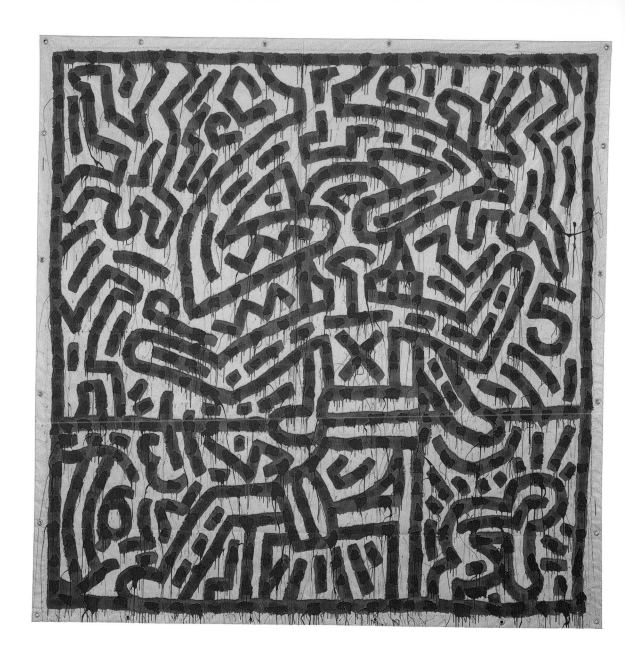

Untitled, 1982
Vinyl ink on vinyl tarpaulin, 274 x 277 cm
Private collection

strokes, he sketched the picture itself, which he never signed. In this way he developed a series of simple and comprehensible motifs, among them variations on the UFO theme, his dog, or his line figures. Many of the drawings stand by themselves, while others constituted a short storyboard similar to a comic strip, or else a narrative was spread over a number of subway stations. Interestingly, his subway drawings, in spite of, or perhaps precisely because of their vulnerability, were rarely damaged or scribbled over. Haring adapted each motif to the format of the existing empty space. Thus he would place a tower of seven figures sitting on each other's shoulders in a vertical format, for example (ill. p. 21 left), their arms alternately outstretched or akimbo. The human pyramid is a motif that Haring absorbed by watching the dance poses of Electric Boogie. In his chalk drawings, the pose takes on exaggerated, almost threatening proportions, an aspect emphasized by the strokes to the sides. Another drawing (ill. p. 21 right), however, emanates more tranquility. The simple gesture of the pair of figures, one clasping the shoulders of the other, implies friendship, trust and affection. The loving intention is underscored by the hearts drawn on the breasts.

As though subjecting his public to a learning process, Haring introduced his figures gradually, following the principle of simple comprehension. The pictorial structure was conceived for a public who were running or riding past and needed to be able to grasp the simple motifs at a fleeting glance. Keith Haring drew on a fund of constantly recurring signs in ever new, or minimally changing combinations. He treated his signs as modules whose meanings could change according to their configuration. These fragile drawings functioned as interruptions between the large advertising posters, but they themselves contained no consumer-oriented messages. On occasion, Haring alluded to the content of the nearby advertisements. The confusions thus caused led in turn to greater attention. In the form of a lion mask, Haring commented on the roaring lions motif of the adjacent poster (ill. p. 20).

To regard the subway drawings merely as entertainment or as decorative gap-fillers would, however, be to mistake their original intention. For his figures and themes, unlike those of Walt Disney, are no mere husks, but are the bearers of particular messages. Thus in two successive pictures, Haring is able, in just a few strokes, to sketch the alleged dream of money (ill. p. 22). The initial joy, represented by the cheering figures hurrying past, is transmogrified into avarice, and the ending in the following picture is anything but happy. The initial cheers are transformed into fear and terror. One comparatively many-layered drawing dates from 1985 (ill. p. 23). Horned robots and monstrous beings dominate the scene. The role of the human figures, by contrast, is submissive and subordinate. Even an angel is caught in the claws of the devilish creatures, and the saving rays of the UFO can only penetrate with difficulty.

With this form of naive genius, Keith Haring disseminated simple truths that needed no precise explanation. The simple and emblematic matchstick-men got through to a public numbered in millions. The mere attention of the passers-by and the many conversations with them about his work gave Haring a real link to the external world. In response to people's questions, he had buttons made with his tags, which he distributed free of charge to the curious public (ill. p. 32 top). The subway drawings were conceived as temporary, which, at the latest, would be pasted over at the start of the next advertising campaign. However, Keith Haring's increasing fame triggered a veritable boom for his art, so that many of the drawings were removed and marketed by passers-by not long after they were executed.

Untitled, 1982
Vinyl ink on vinyl tarpaulin, 213 x 213 cm
Sydney, Australia, Museum of Contemporary Art

Untitled, 1981
Enamel on metal, 121 x 121 cm
Private collection

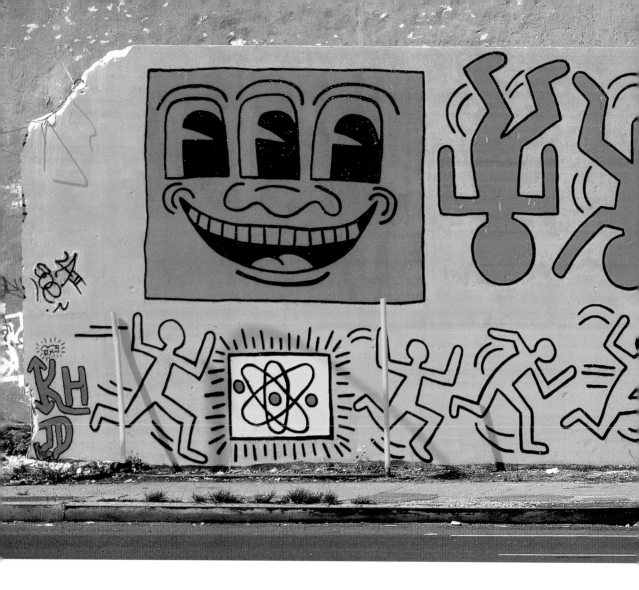

Shortly after covering the New York subway network with his first drawings, Haring made his first profits from sales of his pictures. As time went on, he realized that he could not act as his own dealer. Increasingly frequent visits from interested collectors were robbing him of valuable time, which he could not then use for his art. The search for a suitable gallery seemed inevitable, and so it was that in 1982 Tony Shafrazi became his New York dealer—the gallery owner as whose assistant he had earned a few dollars on the side just two years earlier. Together they planned his first large solo exhibition for October 1982. Haring, who until then had largely concentrated on drawing, now wanted for the first time to show large-format paintings. It was while preparing for this exhibition that he discovered vinyl tarpaulins as the ideal surface for painting. These industrially produced protective sheets were not only obtainable in any size he liked, but were also available in garish colors. With holes punched at regular intervals

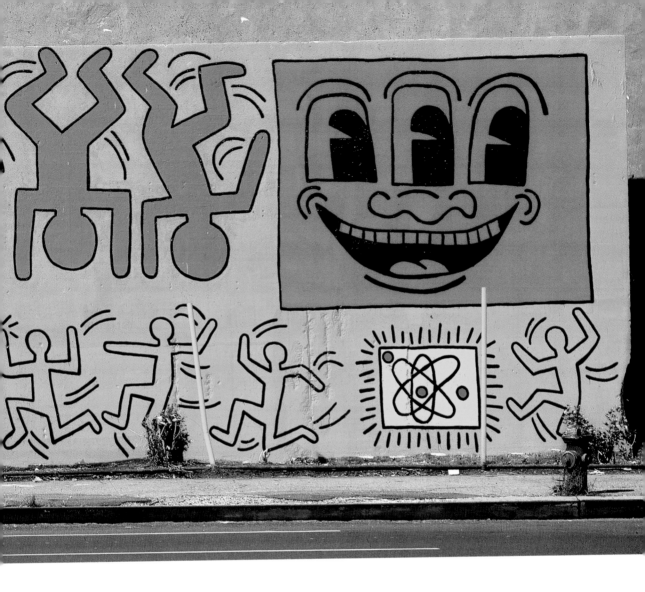

around the edges, the tarpaulins were easy to hang, and also even easier to transport. On these tarpaulins, Haring used a special vinyl silk-screening ink that allowed rapid and almost drip-free application. But it was not just for technical or aesthetic reasons that he initially decided on this surface. "Tony and I decided that I would have my first one-man show in his new gallery in October of 1982. It became an incredible event. Now, during this time, I had just been drawing, and for the show I wanted to do some big painting, which I had resisted doing all (?!) along. The reason was that I had an aversion to canvas. I always felt I would be impeded by canvas, because canvas seemed to have a certain value before you even touched it. I felt I wouldn't be free, the way I was working on paper—because paper was unpretentious and totally available and wasn't all that expensive. Also, for me, canvas represented this whole historical thing—and it just psychologically blocked me."

Mural by Haring, Houston Street, New York, 1982

Painting murals was another way in which Haring communicated with a mass audience, at first in New York and then all over the world.

29

Keith Haring painting a replica of the bust of
Michelangelo's *David*

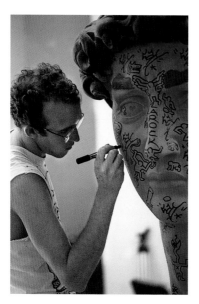

For this exhibition, which was accompanied by a catalogue for the first time, Keith Haring followed the principle of the works created in situ. Alongside the display of drawings and works on vinyl, he also integrated the walls of the gallery into his all-over concept, covering them with his typical figures and line elements (ill. p. 24/25). Between the frieze of running and dancing figures, crawling babies and drawings of Mickey Mouse and Smurfs, he hung the works on vinyl. Motif-wise, these evolved from the subway drawings. The pictures, whose structure was amazingly simple and highly graphic, focused on easily comprehensible themes once more, like two embracing figures surrounded by a halo of rays, or the motif of the dancing dog (ill. p. 27 top). His paintings were executed following the same procedure as his drawings. First of all he painted a frame for the picture, before using just a few brush-strokes of even breadth to sketch the contents. While his subway drawings were oriented to the contrast of black and white, the vinyl tarpaulins allowed him to work in polychrome. Nonetheless, Haring worked with a minimal palette, distinguishing solely between outline and fill color. Roy Lichtenstein, Robert Rauschenberg, Sol LeWitt, Richard Serra and Francesco Clemente attended the opening of the exhibition, which formally launched Haring's meteoric rise to fame.

The absurd figure with a hole in its belly allowing it to function as a hoop for acrobatic dogs to jump through is an allusion to a specific event (ill. p. 33). This motif, which Haring had already employed in his subway drawings, was, according to his own account, his way of coping with the murder of John Lennon in 1980. "It had this incredibly sobering effect on the entire city. I woke up next morning with this image in my head—of the man with a hole in his stomach—and I always associated that image with the death of John Lennon." Quite apart from the countless variations of figures, babies and dogs, one constantly recurring figure is the three-eyed smiling face, which was to be seen at the exhibition in the form of a painting in enamel on sheet metal (ill. p. 27 bottom). This cartoon-like image with its broad smile and big eyes puts across an altogether positive signal to start with, which however, because of the third, unnatural eye, is disturbed in a somewhat creepy fashion. A mural painted by Haring on Houston Street in 1982 evinces the same eerie quality (ill. pp. 28/29). For the mural, he used fluorescent paints, which can be made to glow when exposed to ultra-violet light. Haring also used these paints for a series of sculptures which were based on three-dimensional objects, mostly reproductions of classical busts and columns, and which were primed with the fluorescent paint. Haring would then totally cover the painted objects, for example the head of Michelangelo's *David*, with his signs and abbreviations (ill. p. 31). Many of these sculptures were executed in collaboration with the 14-year-old graffiti artist Angel Ortiz, whose tags, LA II and LA Roc, caught Haring's eye during a nocturnal stroll through the city. Haring was so taken by the painterly perfection of Ortiz' tags that he proposed that the two collaborate. In the following years, Haring and LA II executed many projects together, and exhibited their collaborative works. The surfaces they worked on together consisted mostly of a combination of LA II's tag and Haring's line elements and abstract signs.

The exhibition was followed by a series of events in rapid succession that led to a steady increase in his popularity. Every 20 minutes for a month, a large-format Spectacolor Billboard in Times Square in New York showed a 30-second animation of his icons, a project sponsored by New York's Public Art Fund (ill. p. 32 bottom). At the same time, various institutions in Europe were beginning to show an interest in this unusual artist. Long before Haring achieved artistic

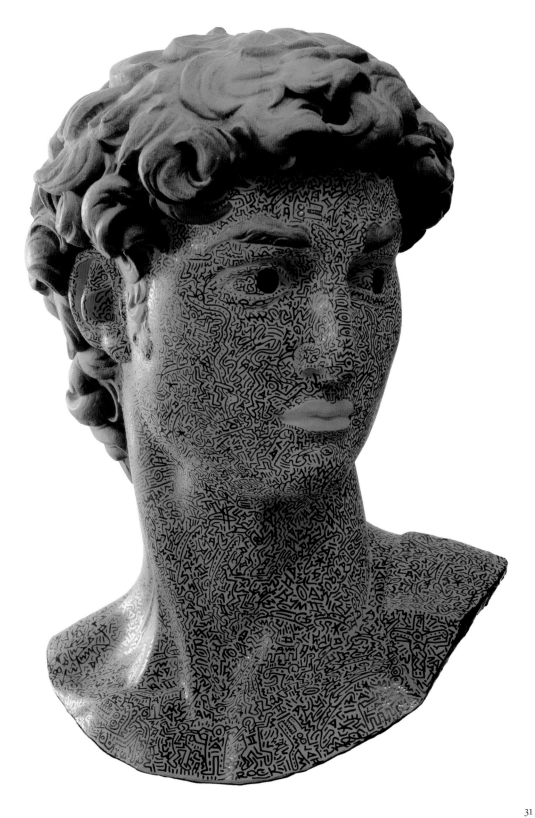

Haring's "radiant baby" button

respectability in America, he was acknowledged and admired on the other side of the Atlantic, not least at the museum level. An invitation by the Dutch Office of Culture resulted in a trip to Rotterdam, followed by a visit to the Stedelijk Museum in Amsterdam. In the fall of that year, Haring was represented at the seventh *documenta* exhibition of contemporary art, held in the German city of Kassel, by two large-format works on vinyl tarpaulins. In just a short time, his art had taken him to the Netherlands, Belgium, Germany, Great Britain, Japan and Italy. On all his journeys, he left his mark on the cityscape in typically public fashion. His name and his art became well known in a very short time. Inquiries and offers came flooding in from all over the world, and Haring found himself incapable of coping with the consequent organizational problems on his own, transferring many of these responsibilities to Julia Gruen, whom he employed as his assistant.

His private life was not uneventful either. At last, after numerous unsuccessful relationships, Haring met Juan Dubose, an African-American DJ, who became his long-term partner and support. In the spring of 1984, Haring staged his first "Party of Life" to mark his birthday, a decision motivated by his desire to allow his friends to share in his steadily growing success. For this purpose he hired the entire Paradise Garage, commissioned his friend the singer Madonna to provide the musical entertainment, and designed special T-shirts, which were distributed among those present. His biographer describes a heady party with 3,000 guests.

Spectacolor Billboard, Times Square, New York, 1982

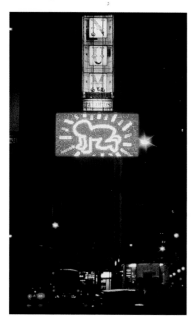

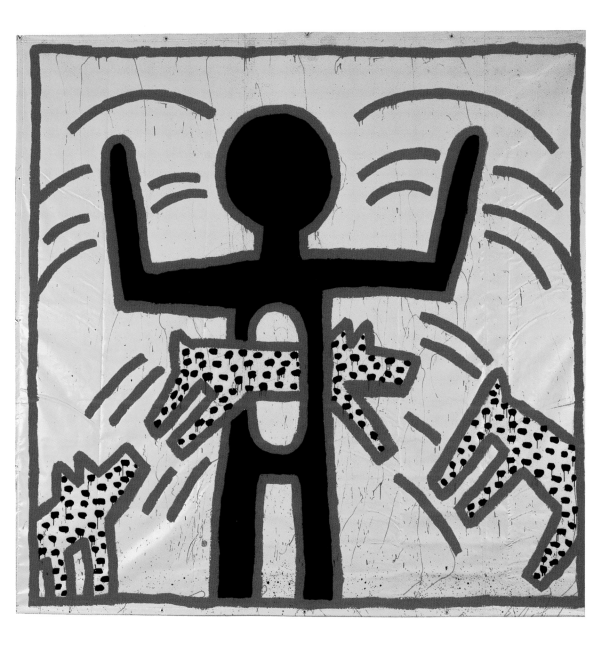

Untitled, 1982
Vinyl ink on vinyl tarpaulin, 366 x 366 cm
Courtesy Tony Shafrazi Gallery, New York

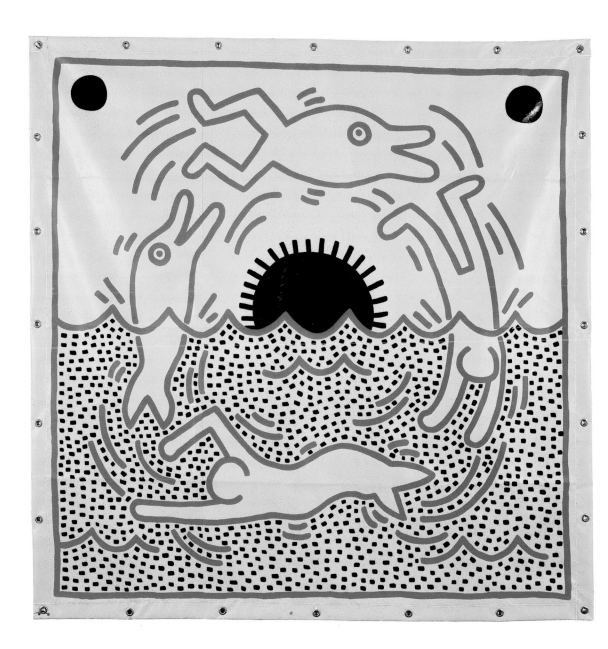

Art, Commerce and Children

Authenticity is an essential feature of Haring's works. In spite of their striking, easy-to-read imagery, his pictures convey a particular feeling for life, expressing sensations whose validity ranges from the personal to the general. The contrived use of a monochrome ground, the rapid and fluent course of a line of constant breadth, and a simple repertoire of forms designed to ensure instant recognizability, are the characteristic features of works with an immediate effect. For this reason, his images achieved an iconic status: the name Keith Haring was and continues to be primarily associated with the graphic painting style in which areas of luminous color are outlined in thick black contours. These lines are not just drawn for reasons of purely formal demarcation, but enjoy an aesthetic status of their own. The artist's preferred palette comprises the colors red, blue, yellow and green. Applied unmixed and in large patches, they create a shrill signal effect with no highlights or shading whatsoever. As far as motifs are concerned, Keith Haring had recourse primarily to those visual sources by which he himself was surrounded. From the archive of his personal experiences he drew the modules of his art, while at the same time continually varying the compositions of his works. The picture is dominated sometimes by a single figure, sometimes by many things going on at once. What we have are narratives or moods, but often no specific message is offered.

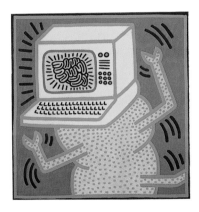

Untitled, 1984
Acrylic on canvas, 152 x 152 cm
Private collection

Alongside the pure-fantasy motifs, there are works that do address particular themes. The painting *Untitled* dating from 1983 (ill. p. 44 bottom) is an homage to the family. A yellow line on red sheeting represents the outlines of two pregnant women, who, dancing, extend a hand to each other, flanked by stylized spermatozoa. Between them, somewhat in the background, is a male figure, which is likewise stretching his arms upward. In the center, lording it over the entire scene, is the crawling baby within a radiant halo. In contrast to Haring's previous works, the contour is additionally marked by short strokes, and the intermediate spaces are entirely filled with dashes and action lines. Only in the bulging abdomens of the women can these otherwise non-representational dashes be interpreted as representing babies growing in the womb.

One much misunderstood aspect of these mostly colorful pictures is the seemingly childlike iconography. It is true that in these works, Haring intentionally has recourse to known precursors from the worlds of fairy-tales and animated cartoons, but to call him a children's artist on this account would be wrong.

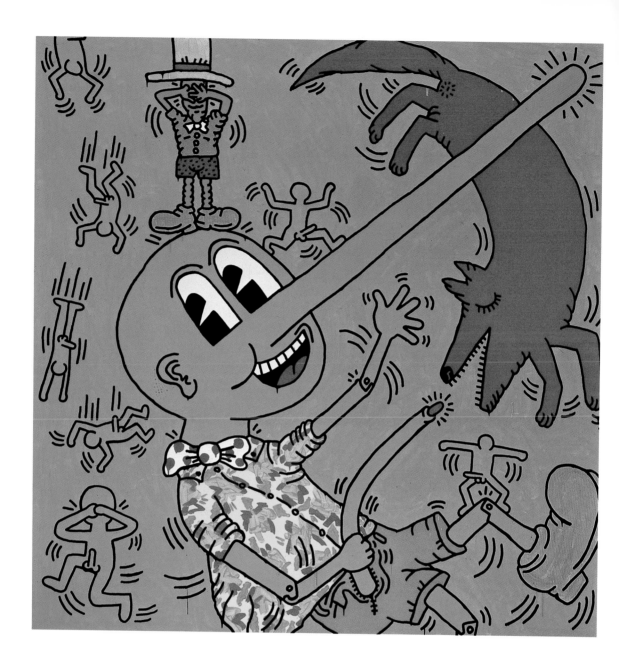

Untitled, 1984
Acrylic on canvas, 239 x 239 cm
Courtesy Per Skarstedt Fine Art, New York

Keith Haring's version of the Pinocchio figure comes
across as anything but child-friendly.

The parallels with Walt Disney's figures are undeniable, but their reading is geared to an alienated form that cannot always be called child-friendly by any means. Haring exploits this instant recognizability in order to confuse the viewer. Similar as it is to the three-eyed smiling face (ill. p. 27 bottom), the expression on the face of the wolf comes across at first sight as friendly, an impression conveyed by the big rolling eyes (ill. p. 37). However, the animal's benevolent gaze distracts from its threatening jaws and teeth. In combination with the lascivious red tongue, the primary pictorial statement is now transformed into its opposite. In the center of another work is the well-known figure of Pinocchio, easily identified by the long nose and the articulated joints (ill. p. 36). Haring interprets the notorious liar as a phallic figure, who joyfully displays his elongating sex and has little in common with the character on which he is based. Elsewhere, Haring uses the fur-crazy animal-tormenting figure of *Cruella De Vil* (ill. p. 38) from Walt Disney's story of the 101 Dalmatians. The face of the woman, depicted in profile, resembles a mask. In addition, wrinkles and conspicuous veins disfigure the originally immaculate image of this sophisticated woman.

Alongside Walt Disney and Co., the everyday lives of Haring's generation were marked by such topics as nuclear power stations and space technology. One diary entry shows that the artist was aware of this contradictory situation. "Born 1958, the first generation of the Space Age, born into a world of television technology and instant gratification, a child of the atomic age. Growing up in America during the sixties, with news about the war from *Life* issues about Vietnam. Watched riots on the television, in a warm living-room, more or less secure in the America of the white middle class." Haring was a vehement opponent of nuclear power.

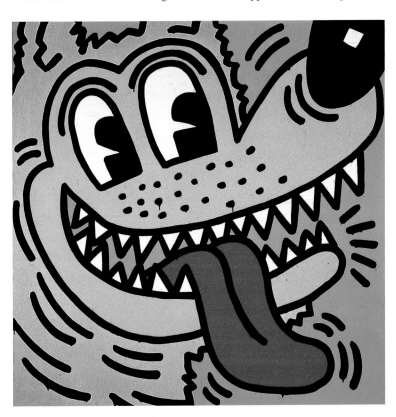

Big Bad Wolf, 1984
Acrylic on muslin, 102 x 102 cm
Private collection

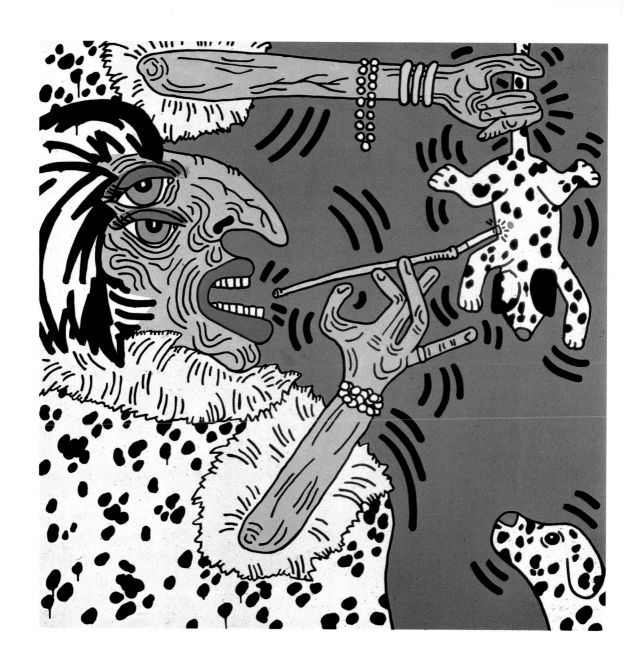

Cruella De Vil, 1984
Acrylic on canvas, 152 x 152 cm
Regensburg, Germany, Gloria von Thurn und Taxis Collection

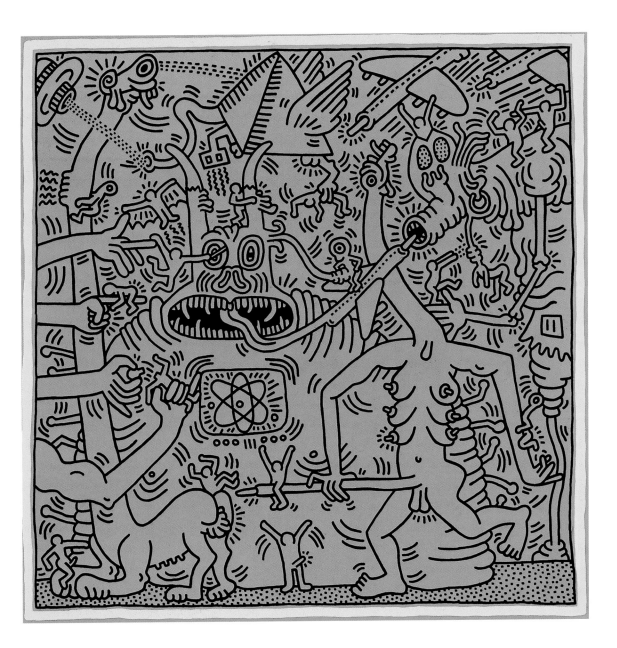

Untitled, 1984
Acrylic on canvas, 239 x 239 cm
Courtesy Per Skarstedt Fine Art, New York

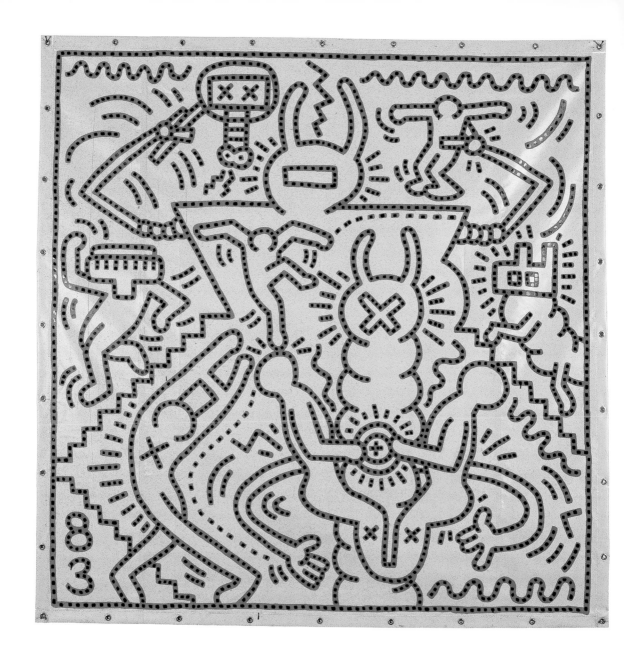

Untitled, 1983
Vinyl ink on vinyl tarpaulin, 213 x 213 cm
Private Collection

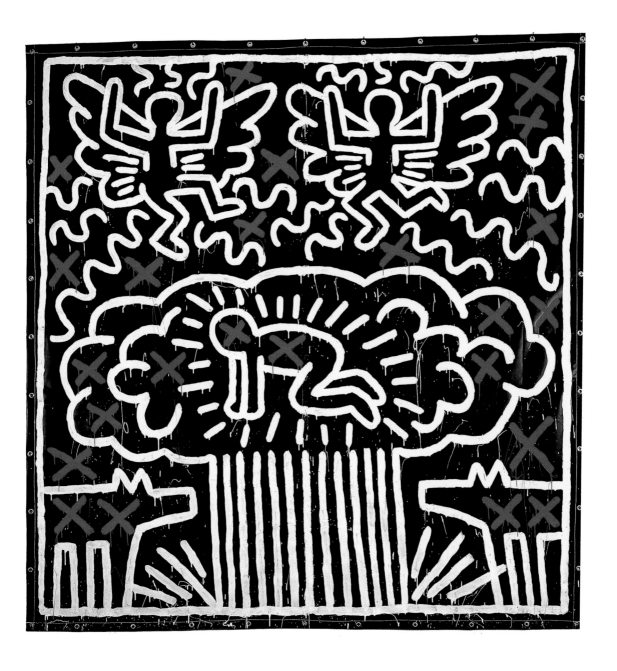

Untitled, 1983
Vinyl ink on vinyl tarpaulin, 305 x 305 cm
Private collection

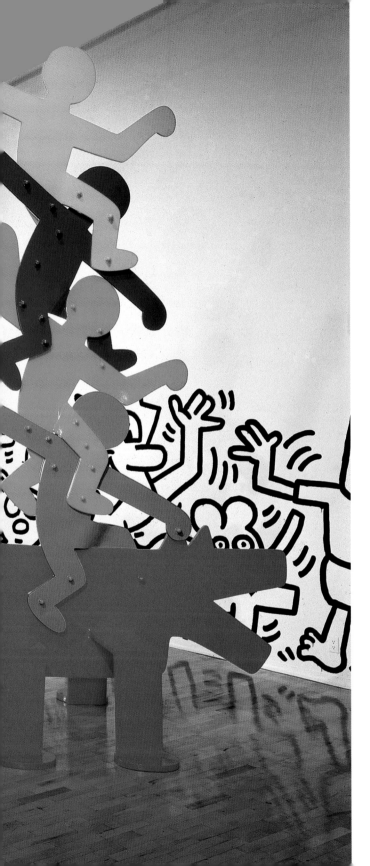

Julia, 1987
Polyurethane enamel on aluminum,
61 x 50 x 37 cm
Courtesy Deitch Projects, New York

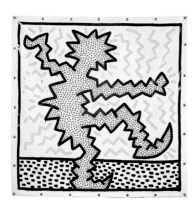

Untitled, 1983
Vinyl ink on vinyl tarpaulin, 183 x 183 cm
Private collection

Untitled, 1983
Vinyl ink on vinyl tarpaulin, 213 x 213 cm
Private collection

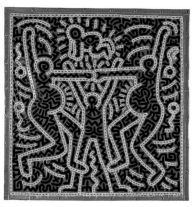

He took part in public demonstrations and designed posters with anti-nuclear slogans, which he distributed free of charge at these events. One painting, composed by the artist in his characteristic sign language (ill. p. 41) tells of the terrors of the atomic age. In white paint on a black sheet, it depicts the crawling baby in the center of a nuclear scenario, thus surrendering the symbol of life to annihilation. Thick red crosses, utilized as negative markings, are scattered over the whole surface. The minimalist technique emphasizes the urgency of the message.

No less urgent and no less horrific are the paintings pointing to the negative effects of technological progress. Haring created grotesque scenarios in which greedy monsters and horned robots play a dominant role (ill. pp. 39, 40). Human beings, by contrast, are presented as small, subordinate entities, transformed into headless and thus biddable creatures. Elsewhere, the dominance of technology is depicted as a millipede with a computer in place of a head (ill. p. 35). Technology has come to replace man as a thinking being. Haring was perfectly well aware that his pictures were, in part, absurd. "The symbols explain themselves and are altogether simple, but their combination, the way in which they go together or exclude each other, is sometimes contradictory. There is no clear path from A to B, just as hardly anything ever has the same meaning … Many different thoughts exist at the same time. As in a dream, one thing makes sense and another thing doesn't, and yet both together depict reality."

The thematic orientation of his works is not restricted just to general or socio-critical aspects, but also documents entirely personal interests such as dance. Dance and music were for Keith Haring essential components of his creativity. While he worked, he would listen to hip-hop music played at full volume in his studio. In addition, he was himself a passionate dancer. Visits to his favorite club, the Paradise Garage, were part of his weekend ritual. Whenever possible, Haring arranged his foreign trips so that he could be back in New York in time for Saturday night. The many dance scenes in his artistic output bear witness to this passion. His pictures reflect the spirit of hip-hop, break dance and Electric Boogie. A prime example is the 1983 picture *Untitled* (ill. p. 44 top). The figure's ecstatic movements result from the logically consistent transfer of Electric Boogie to the medium of painting. His figure, otherwise sketched with gracefully curved lines, is here composed throughout of zigzag strokes. The usual action lines come across as flashes of lightning, which emphasize the theme of electricity once more. Captured in their rhythmic movements and acrobatic distortions Haring's figures seem to be moving to the sounds of the music (ill. p. 48). The movements of his figures are indeed based on genuine poses from break dance. This dance is characterized by wavelike movements, which are transferred from one dancer to the next via the arms, and by headspins or handstands. Occasionally the action also leads to interactive poses between two dancers, represented by Haring as mutual fusion (ill. p. 49).

Haring was especially interested in the Capoeira, a form of Afro-Brazilian martial arts that is performed by at least two participants. He became acquainted with this art form during his frequent visits to Brazil. In his pictures, the focus is on the figures and their movements, without any explanatory context, while in his steel sculptures, the artist succeeds, in a highly impressive fashion, in giving expression to the particular characteristics of the dance. To one such sculpture, dating from 1987, Haring gave the explicit title *Untitled (Capoeira Dancers)* (ill. p. 45 right). The scene is determined by two figures who are shown dancing around each other, each seeking to assess the other's capabilities, whereby the nimble-footed green figure succeeds in avoiding the attacks of the red antagonist.

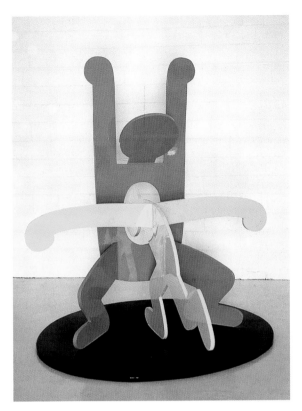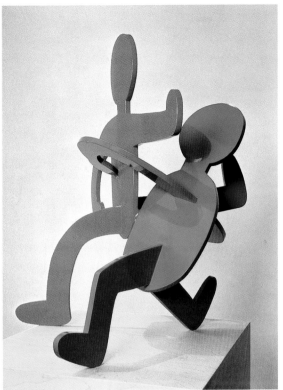

ILLUSTRATION LEFT:
Untitled (Head through Belly), 1987/88
Polyurethane enamel on steel,
143 x 142 x 130 cm
Private collection
Courtesy Galerie Hans Mayer, Düsseldorf,
Germany

ILLUSTRATION RIGHT:
Untitled (Capoeira Dancers), 1987
Polyurethane enamel on aluminum,
72 x 56 x 64 cm
Private collection

During a subsequent phase of the dance, direct bodily contact takes place, and this forms the focus of another sculpture. The title *Untitled (Head through Belly)* is here represented quite literally (ill. p. 45 left). The pose of the protagonists, who are of different physical size, demonstrates the attack by the smaller yellow figure, whose head is projecting through the belly of the larger partner. The delicate sculpture *Julia* (ill. p. 43), by contrast, is inspired by classical dance. It is a portrait of the artist's assistant, created by Haring in 1987. In a manner uncharacteristic of his sculptures, the head of the dancer, inclined to one side, as well as her legs, are detached from the rest of the body, which is otherwise all in one piece. Likewise unusual in this sculpture are the additional rings in the abdominal and pelvic region, which suggest a ballerina's tutu. As in his pictures, it takes just a few attributes to focus on the particular characteristics of classical dance.

Working in three dimensions was for Haring a further possibility of experimenting with new materials and proving his ability as a sculptor. Once he had taken up sculpture, he gave it equal priority with his painting. The maquettes created in his studio were executed as large-format sculptures in a foundry and then painted in bright, not to say garish colors. The first public exhibition of Haring's sculptures took place in 1985 at the Leo Castelli Gallery in New York (ill. pp. 42/43). "Having my sculptures shown at the Castelli Gallery really blows me away, because … well, it's like this holy space! I mean, Johns had done a show there, Lichtenstein had done a big mural there, Rosenquist had worked within the space. For me, it was the perfect time to do something totally irreverent." What Haring meant by this was painting the walls of the gallery with the comic

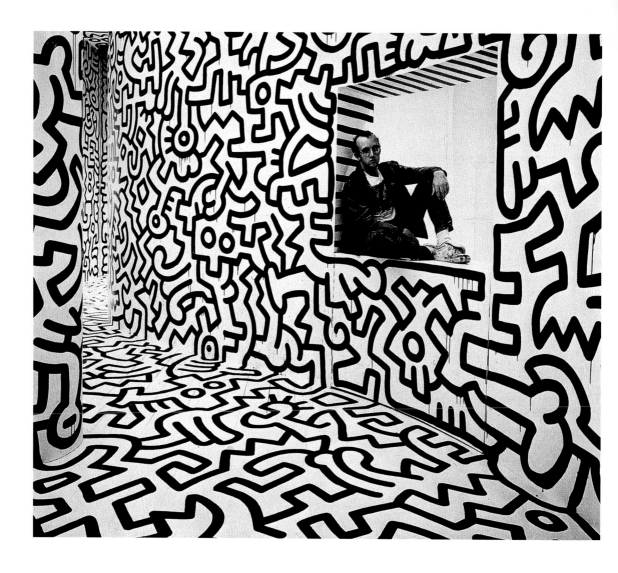

Haring in his *Pop Shop* in SoHo,
Manhattan, New York, 1986

figures that he had already drawn as a teenager, thereby raising the status of his cartoons to that of his art. For a later exhibition, which opened in 1988 at the Galerie Hans Mayer in Düsseldorf, Haring executed large-scale sculptures that were to constitute his largest-ever project in this field of the visual arts. The sculptures were created in a Düsseldorf foundry on the basis of models and maquettes that Haring had made in New York. Alongside small and medium-size sculptures, the collection also included gigantic open-air works for the sculpture exhibition in the German city of Münster. Even today, 14 years after his death, the steel and aluminum sculptures are still being fabricated as the artist would have wished on the basis of original maquettes and editions.

It was not the art community that helped his work to become so enormously popular, but the artist himself. And it was not least for this reason that Haring saw himself confronted with rejection on the part of the established art scene. As an artist, he had simply jumped over the museum and gallery stage, and turned directly and publicly to a mass clientele. Haring himself was the medium for the

dissemination of his art, which expanded in continuous fashion. As an inventor, campaigner and manager all in one, Haring enriched the world with another art celebrity, and he was entrepreneurial enough to know how to market himself. He saw the commercialization of his works as an important component of his art, as an update of the 20th century. In reaction to the need for artistic souvenirs, without further ado he declared his art to be a tradable mass commodity. As a result, his iconic language found its way into everyday culture within a very short time. Even as early as 1983, the first unauthorized copies of his works were already beginning to appear in the form of posters and T-shirts. It was a perfectly logical consequence, then, when in 1986 Haring opened his first *Pop Shop* (ill. p. 46) in Manhattan, selling products bearing his own designs and those of a few select artist friends. In this way he marketed his name as an independent label, without thereby diminishing the value of his art. On the contrary, he saw it as an additional form of artistic statement. The goal was to open his art to an even broader public, to make it accessible to all, and to be constantly present in the form of everyday objects without concealing his commercial intentions. He had of course to face the charge of commercialization made by the critics. As his diaries make clear, he was perfectly well aware that the path between art and commerce that he was treading was a narrow one indeed. "What really fulfills and satisfies me is to make and see things as people react to them, but everything else is difficult. I have tried as best I could to take a new standpoint, a new attitude to selling by painting in full public view and making commercial things which ran in the face of an art-market which talks up goods. But even these things are co-opted and seen by many as mere advertisements for my saleable artworks. I fear I'll never get out of this trap." However, Haring was not primarily concerned with the commercial aspect, but with satisfying the public's ever-growing need to have a share in his art. While traditional merchandising of works of art is based on existing originals, Haring by contrast developed special motifs for his commercial products. Even today, the Haring name is a guarantee of merchandising success. Whatever he produced was distributed and marketed, and also imitated, worldwide.

Where artistic self-marketing was concerned, and how to do it, Keith Haring had the example of Andy Warhol before his very eyes. After Warhol's *Factory*, the establishment of the *Pop Shop* represented a further invention—and a brilliant invention at that—on the part of an artist who knew how to recognize and exploit the reproducibility of his own art. Haring did not want to be exclusively represented by galleries; he also wanted to act as his own dealer, not least in order to maintain his own integrity as an artist and to retain his street credibility. The fundamental difference between these two artists in this respect, and one which shows up in their very different personalities and attitudes to life, consists in the fact that Haring had a very limited interest in "making money" with the *Pop Shop*. He donated the majority of its profits to charitable causes.

The first meeting between Haring and Warhol took place in 1983 on the occasion of the opening of an exhibition of works by Haring and LA II at the Fun Gallery in New York City. Andy Warhol was already a member of the New York society elite, and functioned as a kind of seismograph for the social scene. What interested him would automatically become the object of general interest. A genuine friendship grew between Haring and Warhol, a friendship characterized by mutual recognition, respect and artistic interaction. This ranged from visits to each other's studios to joint projects. Still a young artist himself, Haring benefited from the experience and contacts of someone like Andy Warhol. Conversely,

Untitled (Lil' Keith), 1988
Acrylic on canvas, 100 x 100 cm
Private collection

Untitled, 1988
Acrylic on canvas, 152 x 152 cm
Private collection
Courtesy Alona Kagan Gallery, New York

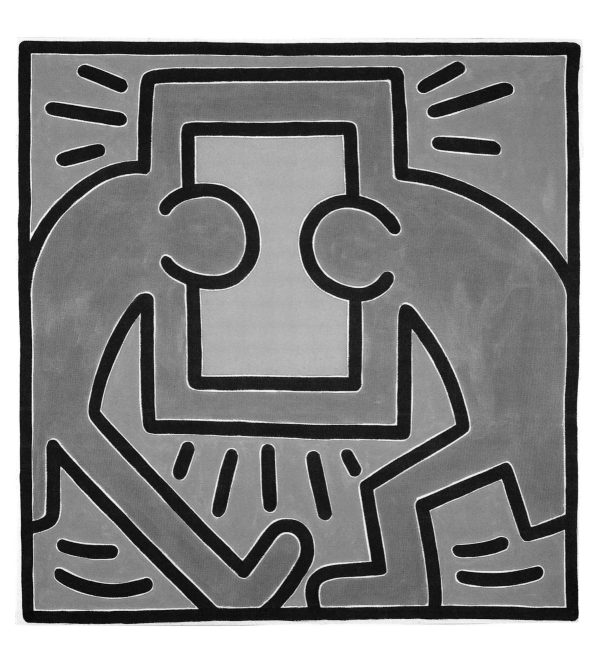

Untitled Nr. 2, 1988
Acrylic on canvas, 152 x 152 cm
Private collection

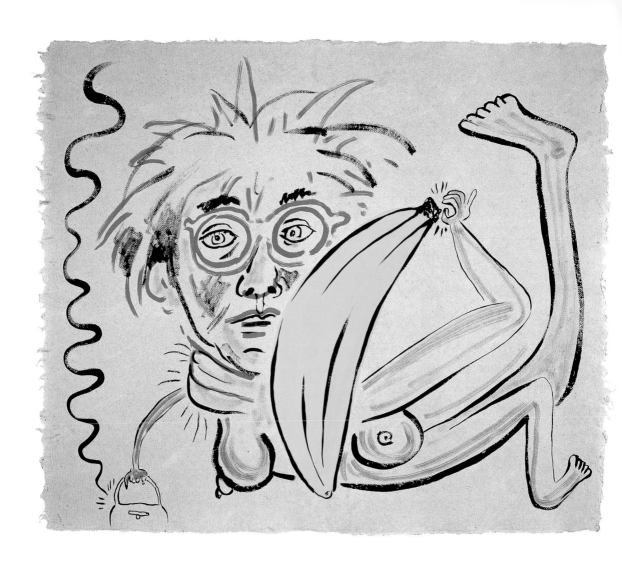

Untitled, 1987
Ink and gouache on handmade paper,
64 x 74 cm
New York, The Estate of Keith Haring

Haring provided Warhol with access to the younger artists on the alternative scene, which in turn Warhol exploited as a source of inspiration. The figure of Andy Warhol turns up a number of times in Haring's work. For his friend he created the figure of "Andy Mouse", based on a Mickey Mouse, which, dressed up in sunglasses and wig, clearly sports the well-known features of Andy Warhol. Duplicated many times, this figure turns up in a large-scale work dating from 1985 (ill. pp. 52/53). Haring saw his friend as the American icon literally borne on the hands of original Mickey Mouse figures and cheered by the broad masses. The background, in red, white and blue, is reminiscent of the Stars and Stripes. A drawing dating from the same year (ill. p. 53) shows similarities to this homage. The motif of Andy Mouse is supplemented by dollar signs in the ears of the mouse. The halo of rays surrounding the figure is unusually jagged. By combining the Walt Disney product with the Andy Warhol product, Haring accords his friend the same iconic status. Fame and glory are accompanied by the demonstrative marketing of art characteristic of Warhol.

It was through Andy Warhol that Haring made the acquaintance of Grace Jones, whom he managed to engage as a model for a body painting. Keith Haring, who had already painted the body of the African-American dancer Bill T. Jones, saw in the singer's body the perfect combination of "primitive" and "pop". Especially for this event David Spada, a jewelry-designer friend of Haring's, created a skirt and a crown that were likewise painted with Haring's motifs. The photographer Robert Mapplethorpe immortalized this unusual collaboration (ill. p. 55).

On February 22, 1987 Andy Warhol died unexpectedly following an operation. Haring, who was on a visit to Brazil at the time, learned of his friend's death over the telephone. In his diary, he wrote: "Andy's life and work made my work possible in the first place. Andy created the precedent for the possibility of my kind

"Art is life. Life is art. The importance of both is over-exaggerated as well as misunderstood."
KEITH HARING, 1978

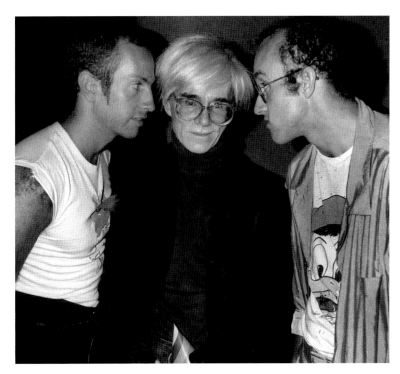

Keith Haring, Andy Warhol and Kenny Scharf at Elizabeth Saltzman's birthday party at Il Cantinori, New York City, June 16, 1986

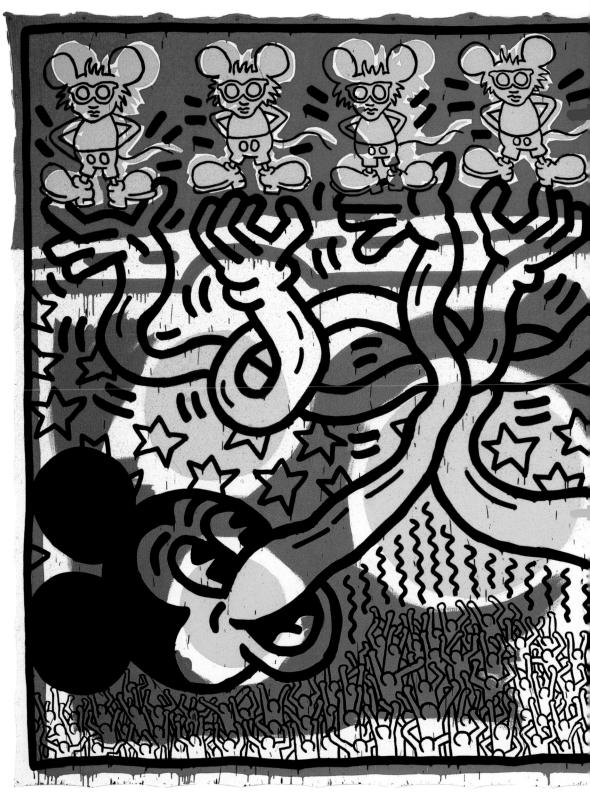

Untitled, 1985
Acrylic and oil on canvas, 305 x 366 cm
Private collection

Untitled, 1985
Sumi ink on paper, 58 x 58 cm
New York, The Estate of Keith Haring

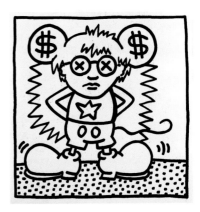

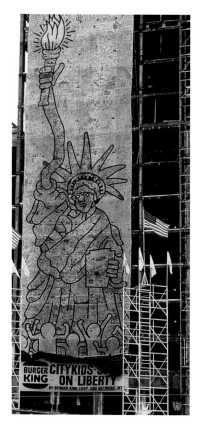

Liberty Banner, 1986
Acrylic on vinyl sheeting, 27.43 m high
The banner with the portrait of the Statue of Liberty is eleven stories high.

of art. He was the first *truly* public artist in a comprehensive sense, and his art and his life have changed our idea of 'art and life' in the 20th century. He was the first truly 'modern artist'. Andy was probably the only real Pop-artist." Just a few days before the death of his friend, he had made a drawing that cast Warhol in a very humorous light (ill. p. 50). The over-sized head of the artist is sitting on a recumbent nude woman's body. In the foreground is a bright yellow banana, whose interpretation as a phallic symbol seems unambiguous. The role reversal and the sexual connotation give the drawing a homoerotic aspect. The loss of his friend was a great blow to Haring. The fact is that, artistically, he owed a great deal to Andy Warhol. However it would be wrong to describe Haring merely as his epigone. Haring himself pointed to one essential difference in an interview with Germano Celant: "My drawings don't try to imitate life, they try to create life, to invent life." It was this claim of wanting to create life that distanced Haring from the goals of Pop Art and indeed from Andy Warhol. While Pop Art drew its themes from pre-existing printed originals, appropriating commercially familiar motifs, the foundation of Haring's work was an impetus that sprang from inside of him.

Although Haring cannot be seen as a children's painter, he was a tireless advocate of children's causes. In the 1980s, public art was strongly promoted, providing an environment in which Haring's art and his commitment to children could be effectively combined. Public commissions and sponsoring measures for projects with children were supplemented by paintings and sculptures with child-related themes. Haring enjoyed contact with children, and not infrequently preferred their company to that of adults. In those pictures painted expressly for children, he returned to the comic style of his youth (ill. p. 47). His commitment to children's causes was multi-faceted. He gave drawing workshops in schools and museums in New York, Amsterdam, London, Tokyo and Bordeaux, and designed motifs for literacy campaigns in Germany and the United States. Many of his public murals were created for, and in collaboration with children. In 1986, on the occasion of the celebrations marking the centenary of the Statue of Liberty in New York, Keith Haring painted an enormous portrait with the outlines of the statue, which was subsequently painted in by thousands of children (ill. p. 54). The banner, which hung across the front of a building, covered more than ten stories. The following year Haring designed and painted murals and a carousel for the Luna Luna traveling amusement park in Hamburg, Germany. As he was regularly surrounded by children and young people whenever he worked in public, he always had plenty of stickers, buttons and coloring books with him, which he would distribute free of charge to his young fans.

ILLUSTRATION PAGE 55:
Body painting, Grace Jones, 1984
New York, The Estate of Keith Haring

In Haring's eyes, Grace Jones embodied the ideal combination of "primitive" and "pop".

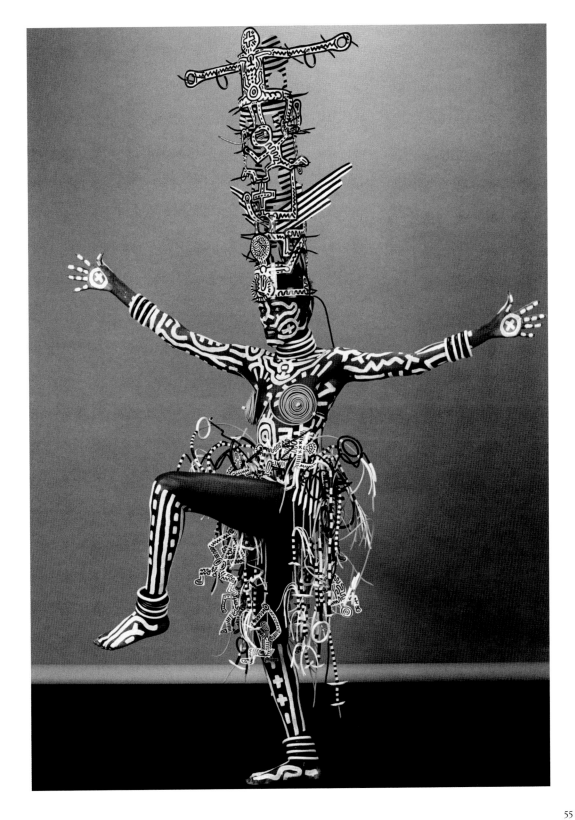

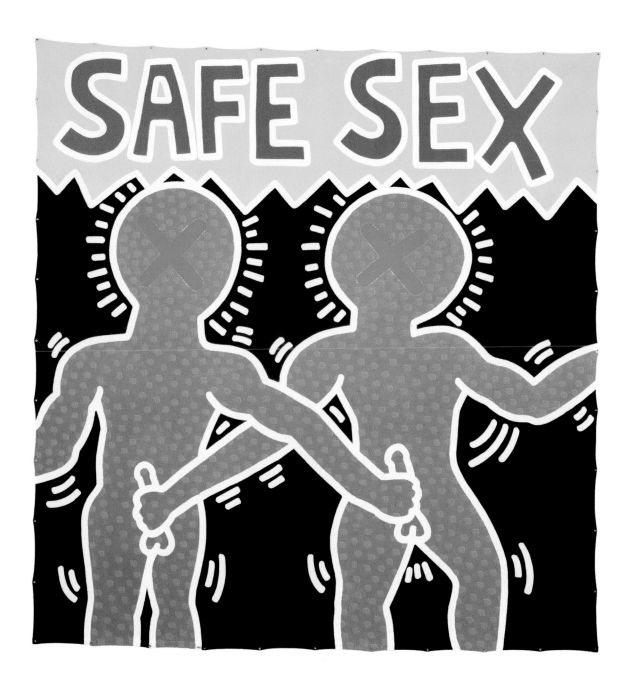

Sex and Crime

Behind the lightness of the pictures lurks the danger that Haring's work will be primarily associated with jolly, cheerful and optimistic themes. However, his themes are anything but jolly, cheerful and optimistic—quite the contrary. The untroubled freedom from care and the demonstrative joyfulness are often coupled with brutal reality. A not insignificant proportion of his paintings is concerned with violence and threats, death and sexual oppression. Only on closer inspection does the darker aspect reveal itself to the beholder. Scenes are characterized by monsters, skeletons, snakes and demons, but also by metamorphosis, both in the bodily and the sexual sense, all of which lend the paintings a frightening and violent note. What is special about this ambiguity, and typical of Haring's art in this respect, is that his imagery is not in any way complicated by this aspect of its content.

The large-format painting *Untitled,* dating from 1985 (ill. pp. 58/59), demonstrates a veritable purgatory of sexual desire. Reduced entirely to the colors black and red, a scenario is revealed against a background of blazing flames, the whole thing reminiscent of medieval concepts of hell. We see, compressed into a confined space, man-eating monsters, along with sexual organs and bodily orifices that have taken on a life of their own, all seeking sexual gratification. At the lower edge of the picture, a number of people are struggling for their lives. This is also the case in another work. But in *Untitled* from 1986 (ill. p. 61), the menacing, sinister atmosphere gives way to a brighter scene, albeit one no less absurd. The theme of sexuality in Keith Haring's pictures nearly always has a threatening, violent and obsessive side. Not infrequently, though, these violent scenes are transformed into their opposites. The brutality of animal sex and boundless violence is often given the appearance of something pleasurable. These pictures are not capable of the unambiguous interpretation typical of the rest of Haring's art. These works perhaps best illustrate, in fact, the tightrope that Haring was constantly walking. The sudden swing from superficially positive to negative, and the continuous subliminal presence of the menacing and the destructive, manages to achieve a remarkable balance.

Alongside the countless copulating couples, the orgies involving human beings, monsters and animals, and the detached male and female sex organs that undergo abstruse metamorphoses, one leitmotif is the theme of sexual self-determination. Haring deals with this basic human right, however, by the use of

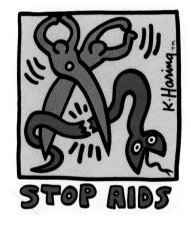

Stop Aids, 1989
Sticker, 13 x 10 cm
New York, The Estate of Keith Haring

ILLUSTRATION PAGE 56:
Safe Sex, 1988
Acrylic on canvas, 305 x 305 cm
New York, The Estate of Keith Haring

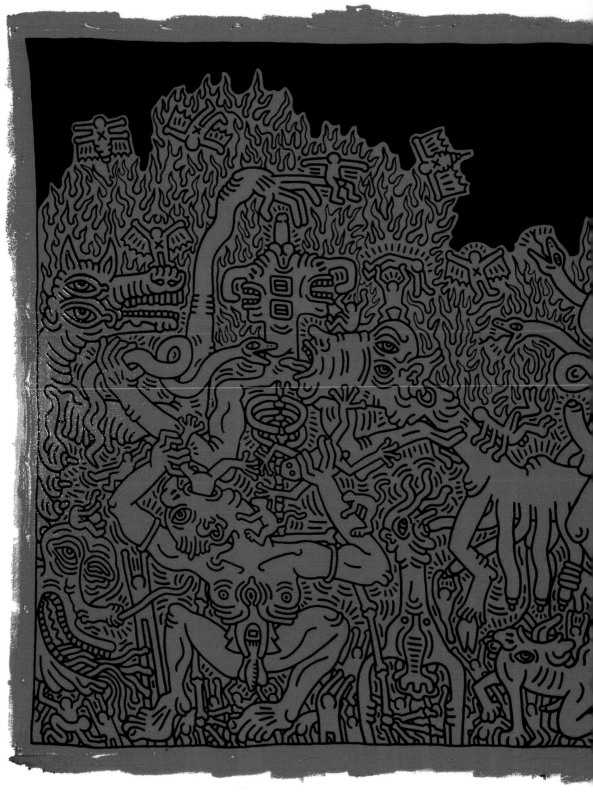

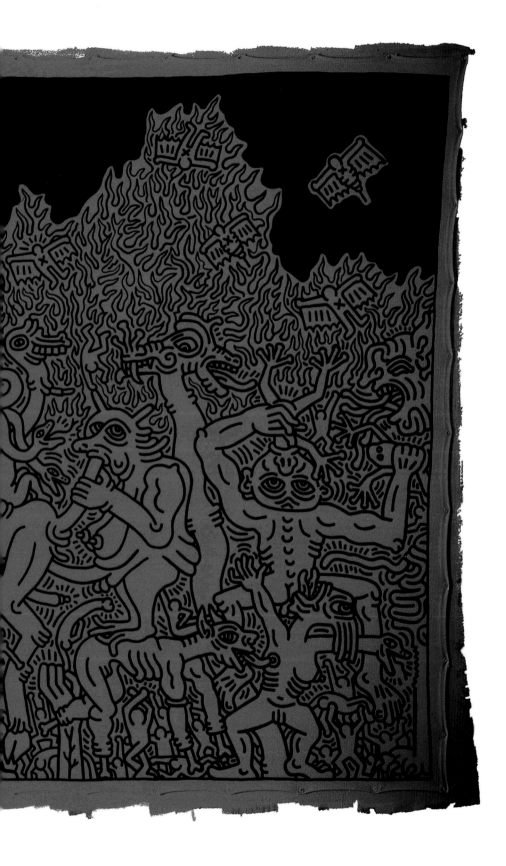

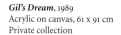

Gil's Dream, 1989
Acrylic on canvas, 61 x 91 cm
Private collection

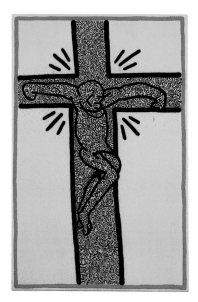

negative examples. Rape, sexual coercion and castration are the most important ways in which this individual sexual determination is violently negated. The brutal frankness of the 1985 *Untitled* (ill. p. 65) renders any further commentary superfluous. In addition, it is given a further political twist by the distinction between a helpless black figure and an active white one.

To his pictorial representations of oppression and maiming, of cruelty and brutality, Haring often adds religious allusions. In fact, Haring's work is imbued with an abundance of Christian motifs. In 1984 the artist was commissioned to create a stage set for a production of the ballet *Le mariage du ciel et de l'enfer* (*The Marriage of Heaven and Hell*, ill. p. 63) in Marseilles, France. The result was a monumental work, which captures the central moment of the marriage, accompanied by the cheering applause of the winged beings that accompany each party. A mighty hand from heaven places a ring on the finger of the hand from hell. The latter hand, receiving the ring, is spread out in the sign of the Devil, which lends the scene a triumphalist element. The picture *Untitled* dating from 1985 (ill. pp. 66/67), conveys in impressive fashion a critical attitude toward the influence of religion and its representatives. Religion, itself a hostage, is portrayed as a fork-tongued and avaricious being that takes possession of human beings in various ways. According to the statement of the picture, the biblical messages lead to the loss of spiritual, emotional and sexual autonomy. The painting technique, otherwise characterized by large areas of color, is supplemented by detailed draftsmanship and color shading. In contrast to this we have the picture *Moses and the Burning Bush* dating from 1985 (ill. pp. 68/69), which deals explicitly with a biblcal theme. The burning bush, through which God makes his covenant with Moses, is a symbol of annunciation; the scene is a dense weave of dancing flames. The outlines concealed within it can only be made out with difficulty. A further elemental symbol from Christian iconography is taken up in the late work *Gil's Dream*, which dates from 1989 (ill. p. 60). The central figure of the crucified Christ, outlined in just a few strokes, merges with the stark contours of the cross. The unity of figure and cross is emphasized by the treatment of the intervening spaces. Although Haring uses religious symbols, he should not be understood as a Christian artist in the traditional sense. It is hard to say how far this Christian symbolism can be described and interpreted as religious. Certainly, in view of actual violence, terror and disease portrayed in his other pictures, the inclusion of these symbols can, in a sense, be interpreted as cynical.

One picture that is unusual in a number of respects is the six-part painting *Untitled* dating from 1984 (ill. p. 75), in which Haring takes a position on a current event . The painting was triggered by the murder of the Italian art-historian Francesca Alinovi, who was found stabbed in her flat in mysterious circumstances on July 15, 1983. Alinovi was one of the first critics to write about the artists, like Haring, who were active on the New York graffiti scene, thus bringing their art to the attention of the European public. In contrast to his usual painting technique, Haring uses a double contour, executed in black on red, of varying breadth and with irregular edges. The field itself consists all over of linked figures, heads, limbs and structures, themselves filled with hieroglyph-like signs in white, yellow and black. Only on closer inspection do recognizable scenes emerge from the general pattern. In the middle of the picture, a hand holding a knife is seen descending and transfixing the body of a figure—clearly the murdered Alinovi—stretched out diagonally across the center of the picture. A witness on the bottom edge observes the scene, albeit with closed eyes. The central event is surrounded by monsters and demons, which in their turn seize and swallow other figures.

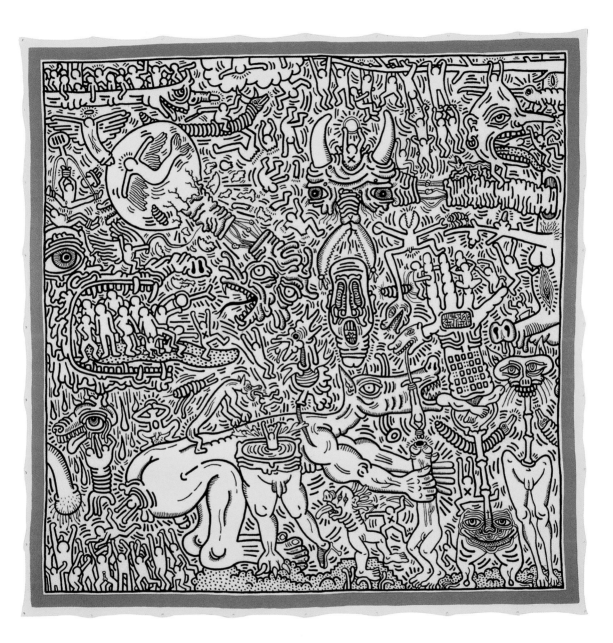

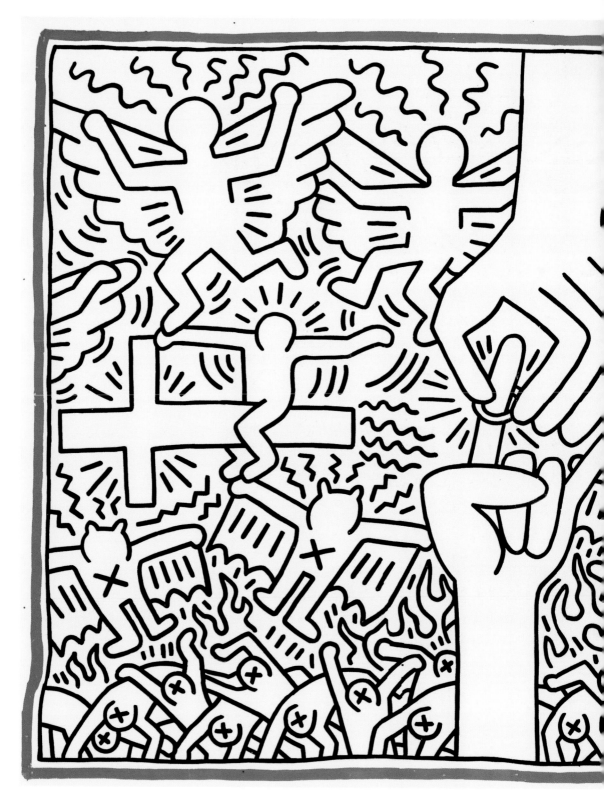

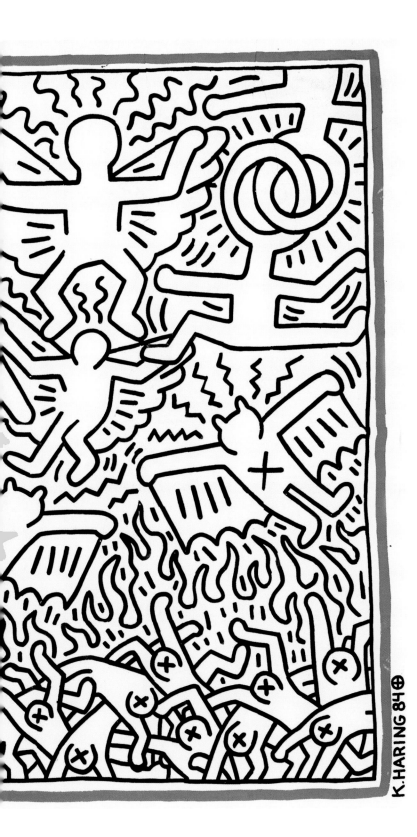

The Marriage of Heaven and Hell, 1984
Acrylic on canvas, 793 x 1118 cm
New York, The Estate of Keith Haring

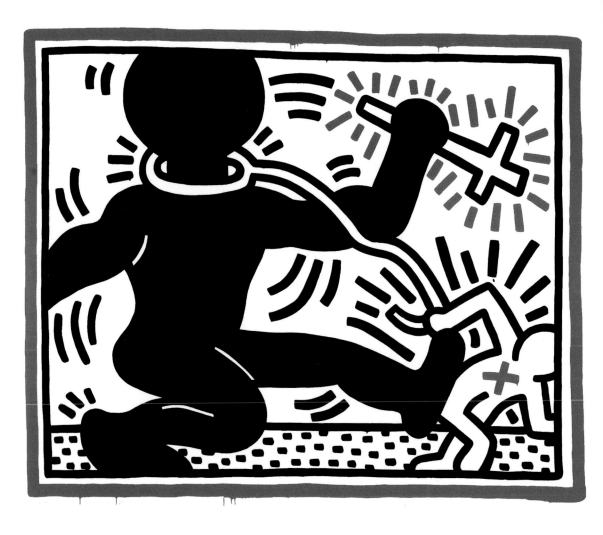

Untitled, 1984
Acrylic on canvas, 305 x 366 cm
Amsterdam, Stedelijk Museum

Haring has painted a diffuse and multi-layered picture of a murder that was never satisfactorily cleared up.

The painting *Michael Stewart—USA for Africa* (ill. pp. 72/73), which dates from 1985, is to be seen as open criticism of the social conditions of the time, pointing to political abuses in his own country. In drastic fashion, it takes up the theme of the eponymous African-American graffiti-writer, who was beaten to death by the police. The victim, depicted with staring eyes and an expression of fear, is being kicked and strangled by unknown persons, while moving along a bloody river of people already helplessly submerged. Potential witnesses cover their faces, and the mighty arm of money is wrapped around his neck. The upright symbol of the cross is transformed into a falling sign. Discrimination goes hand in hand with open violence. In particular, the apartheid system in South Africa, against which Haring painted veritable protest pictures, is a central theme of numerous works. In striking form, the painting *Untitled* dating from 1984 (ill. p. 64), focuses on the glaring gap between the dominant white race and the black majority. This time with a radiant cross in his hand as a weapon, the black figure defends himself with a kick that almost drives his antagonist out of the picture.

Behind this simple gesture stands a direct summons to oppose the existing oppression.

Drug abuse was a further subject against which Haring, through campaigns, murals, and posters, took a personal stand, based on his own participation in and observance of the 1980s drug culture and crack-use epidemic. On a large wall, which, not far from a highway, stands out like a billboard, he painted a mural in bright orange, accompanied by the text *Crack is Wack*, which could be read by the occupants of passing cars. A further medium which he used for educational purposes were posters containing his messages, couched in typical language, many of which he distributed free of charge (ill. pp. 70, 71). Drug abuse

ILLUSTRATION PAGES 66/67:
Untitled, 1985
Acrylic and oil on canvas, 305 x 457 cm
Private collection
Courtesy Alona Kagan Gallery, New York

Untitled, 1985
Acrylic on canvas, 122 x 122 cm
Private collection

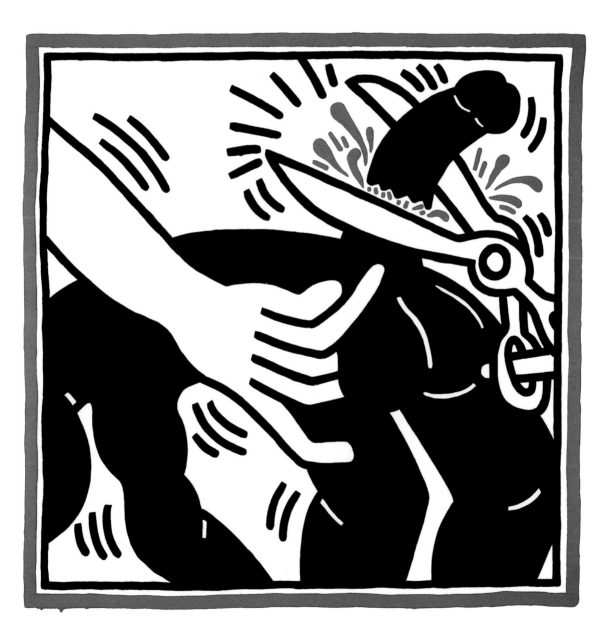

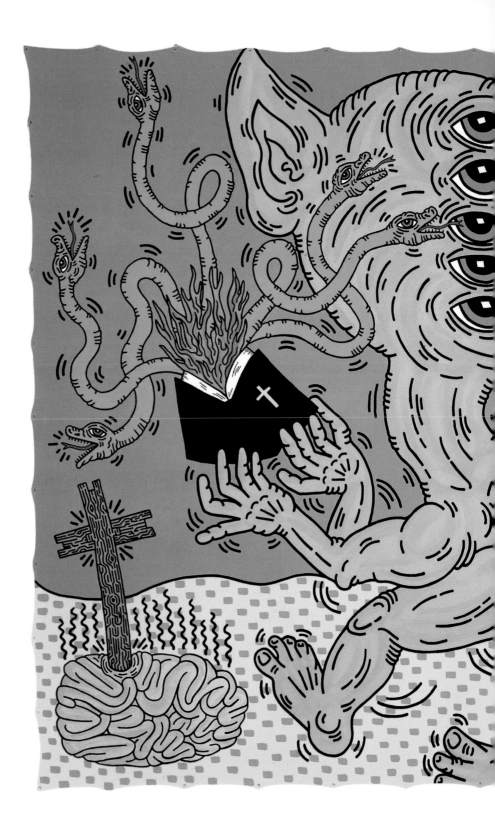

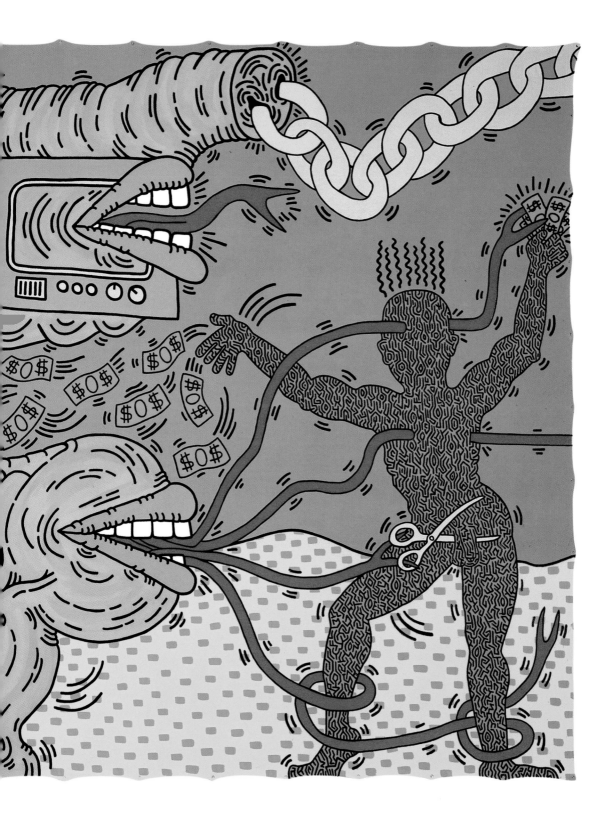

Moses and the Burning Bush, 1985
Acrylic and oil on canvas, 305 x 366 cm
Venice, California, Dennis Hopper Collection

claimed its toll of victims in his personal environment too. In the summer of 1988, Jean-Michel Basquiat died of an overdose of heroin. Haring, who as a friend and an artist, was a great admirer of Basquiat, erected an artistic memorial to him. For the painting *A Pile of Crowns for Jean-Michel Basquiat* (ill. p. 80), painted that same year, he chose a triangular canvas, which, like a warning sign, is edged by a broad red line. In the center looms the eponymous pile of crowns, executed in black and white. Haring expressed his appreciation of his friend through the symbol of the three-pointed crown, the personal tag of Jean-Michel Basquiat.

By the mid-1980s, the theme of AIDS was well entrenched in the public consciousness. Sex was no longer safe and physical desire, celebrated with frequently changing partners, could now be lethal. This was a fact, and Haring saw himself confronted with it in his own circle of friends too. He had already lost many of his friends and acquaintances to AIDS. He was well aware of the danger of falling victim to this disease himself: "Life is so fragile. A very fine line divides it from death. I realize that I am walking on this line." The potentially fatal outcome of this illness had its effect on his own habits. "I didn't stop having sex, but had safe sex or what was considered and understood to be safe sex at that point. I became more conscious of being self-protective. Still, there were all kinds of things you could do, and I kept being more or less active. But by 1985, AIDS had changed New York." Although he had no way of knowing when he might fall victim to the disease himself, in his final years he increasingly painted pictures dealing with the subject of AIDS. These are pictures with a deterrent impulse, designed to save others from the same fate. One memorable and penetrating picture is the large-format painting *AIDS*, dating from 1985 (ill. p. 74). The center is occupied by the head of a death-bringing monster, negatively marked with a red cross on its body, pandering to the manifold sexual desires of its victims by offering itself, groping, embracing, and licking. The victims themselves are driven to an orgasm

Ignorance = Fear, Silence = Death, 1989
Poster, 61 x 110 cm
New York, The Estate of Keith Haring

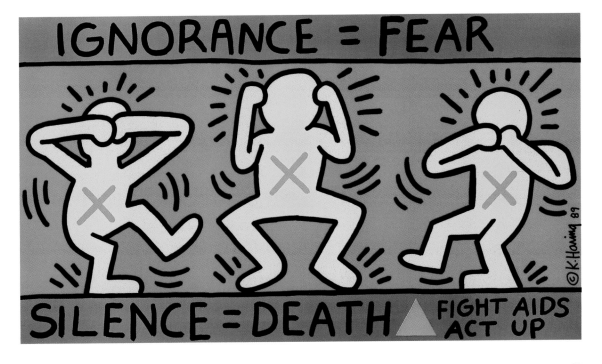

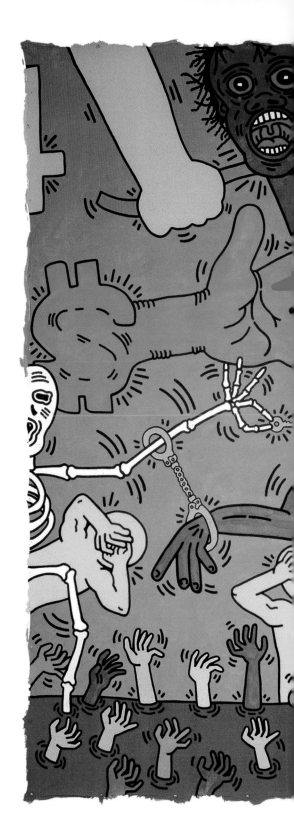

Michael Stewart—USA for Africa, 1985
Acrylic and oil on canvas, 305 x 458 cm
Miami Beach, FL, Lindemann Collection
Courtesy Deitch Projects, New York

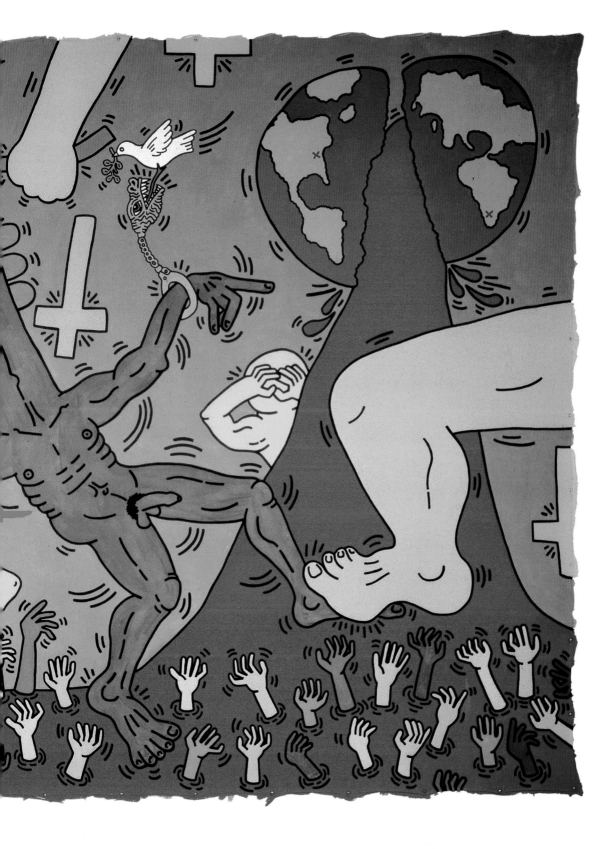

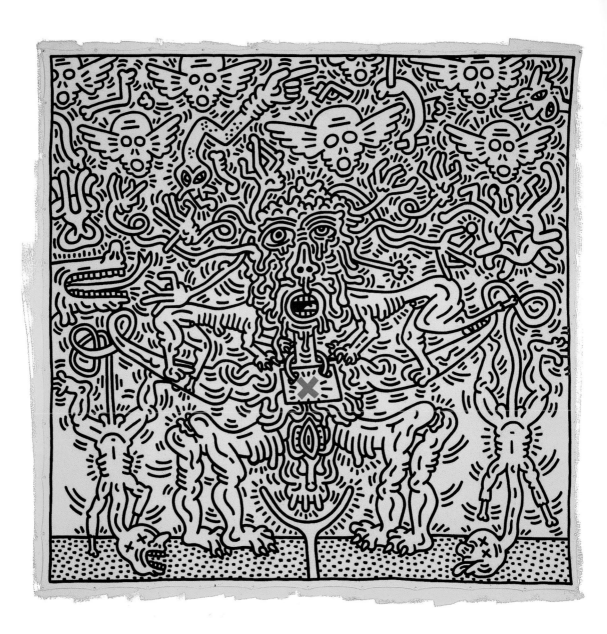

AIDS, 1985
Acrylic and oil on canvas, 305 x 305 cm
Aachen, Germany, Ludwig Forum für Internationale Kunst

culminating in death. Two figures, their eyes obliterated by crosses, are hanging upside down by their genitals, a protruding tongue dragging lifelessly over the ground. The scenario is framed at the top by winged death's-heads.

In a series of drawings dated April 24, 1988, executed in red and black Sumi ink on paper, Haring personifies the virus as a horned sperm (ill. pp. 76/77). In impressive and drastic metaphors, he shows the possible causes of an infection, including the syringes used by drug-addicts, or unprotected sex in the form of male and female sexual characteristics, from each of which a devil's sperm is seen to emerge. In a number of variations, Haring represents the disease as a barely tolerable burden, like a cuckoo's egg that the infected person has to carry around with him. The outbreak of the disease itself is symbolized as the point in time when the devil's sperm emerges from the egg. Interestingly, there is a connection between the content of the pictures and their borders. In contrast to his other pictures, here the bright red border is broken in various places by the horns. The final drawing in this series shows a calligraphically graceful portrait of the sperm. The theme of an immense burden appears once more in a large work dating from 1988 (ill. pp. 78/79). Within a double white border on a black ground, the moment of the outbreak of the disease is captured. Tightly bound to the back of an infected person, laboriously making his way upstairs, the illness breaks out, once more in the form of a giant horned sperm hatching from an egg.

The astonishing casualness and self-assurance with which Haring confronts the abstract notion of death changed after his own diagnosis. "Throughout the eighties, I always knew I could easily be a candidate for AIDS. I knew this be-

Untitled (Painting for Francesca Alinovi), 1984
Acrylic on muslin, 305 x 457 cm
Laupheim, Germany, FER Collection

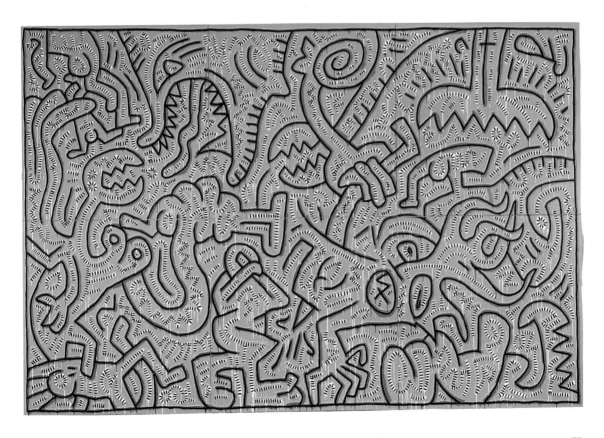

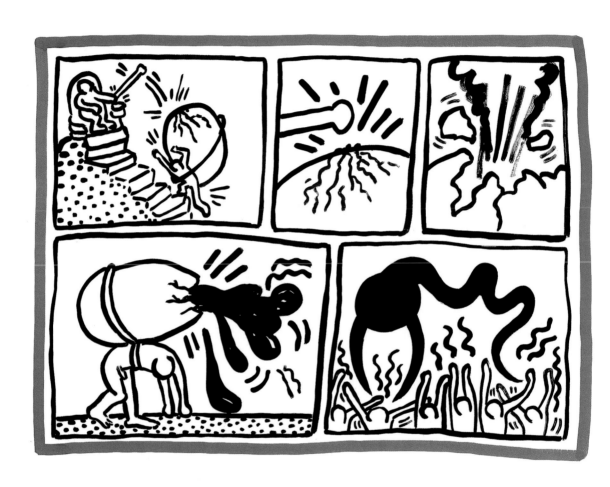

Untitled, 1988
Sumi ink on paper, each 57 x 76 cm and 76 x 57 cm respectively
Private collection
Courtesy Galerie Hans Mayer, Düsseldorf,
Germany

ILLUSTRATION PAGES 78/79:
Untitled, 1988
Acrylic on canvas, 366 x 549 cm
Courtesy Tony Shafrazi Gallery, New York

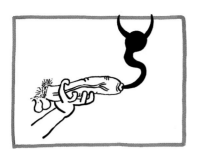
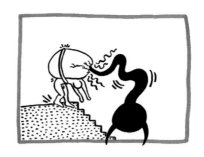

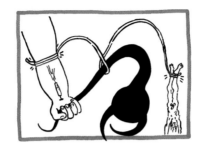

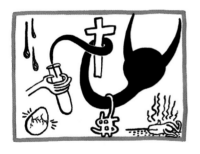
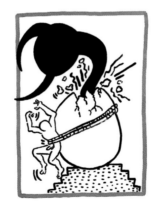

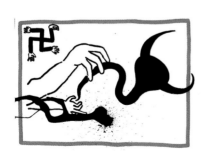
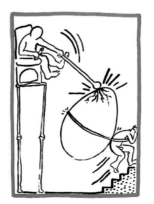

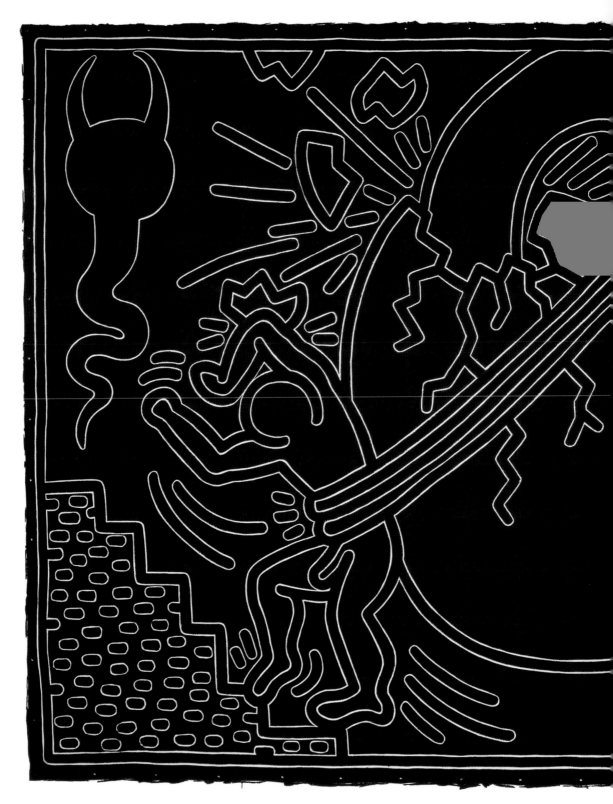

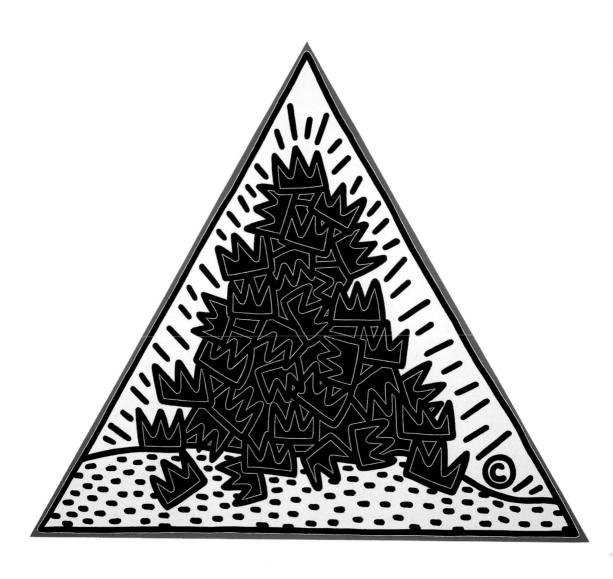

A Pile of Crowns for Jean-Michel Basquiat, 1988
Acrylic on canvas, 305 x 264 cm
New York, The Estate of Keith Haring

cause there was every kind of promiscuity in every corner of New York City—
and I was very much a part of all that." During a stay in Japan in the middle of
1988, Haring noticed purple spots on his body, which on his return were diag-
nosed as the first sign of a disease associated with AIDS. "At first, you're complete-
ly wrecked. You go through a major, major upset. I mean, even though I sort of
expected this to happen, when it actually does happen, you're not prepared. So
the first thing you do, is break down. I went over to the East River on the Lower
East Side and just cried and cried and cried." From then on, many of his pictures
take on a greater sharpness and profundity. His personal situation, caught be-
tween hope and hopelessness, did not cripple his artistic energy, but rather vital-
ized it all the more. As if he wanted to paint against his own fate, he created pic-
tures of enormous strength, including works of propaganda-like character such
as *Silence = Death*, which was painted in 1989 (ill. p. 81). Stark against a black
background, we are confronted by a pink triangle. Layered over the latter, there
is a network of silvery outlined figures that alternately cover their eyes, ears and
mouth: a penetrating picture, urging the beholder to act against intolerance,
ignorance and silence. Thematically, this connection is taken up again in an anti-
AIDS poster (ill. p. 71). The statement "silence = death" is logically extended by
a further slogan: "ignorance = fear".

In the diptych *Untitled (for James Ensor)* of 1989 (ill. pp. 82/83), Haring visual-
izes his conviction that he will live on, not in his body, already condemned to
death, but in his art. The two panels, executed in black-and-white, are numbered
and reminiscent of the subway drawings of Haring's early days. In the first panel,
we see a skeleton with a radiant key in its hand, ejaculating over a flowerbed. In
the next picture, the sperm of death has caused the flowers to grow, to the great
joy of the skeleton. The statement made here is simple. Haring's art will outlive
him, and still shine after he is gone. "Work is all I have, and art is more impor-
tant than life," he wrote in his diary. After he himself had been diagnosed as
HIV-positive, Haring changed his lifestyle. He paid more attention to his health,
and accorded less importance to sex. He focused his waning energy on people he
could talk to, people who provided intellectual stimulation. At the same time, he
separated from his then friend and lover Juan Rivera. Haring, who no longer
wished to be tied down to a partner, sought the platonic friendship of Gil
Vazquez, who became his final, trusted companion. "It now becomes a challenge
to be with someone with whom I'm not having a sexual relationship. I discover
how wonderful it is to have a sharing and caring relationship with someone."

Silence = Death, 1989
Acrylic on canvas, 102 x 102 cm
Private collection

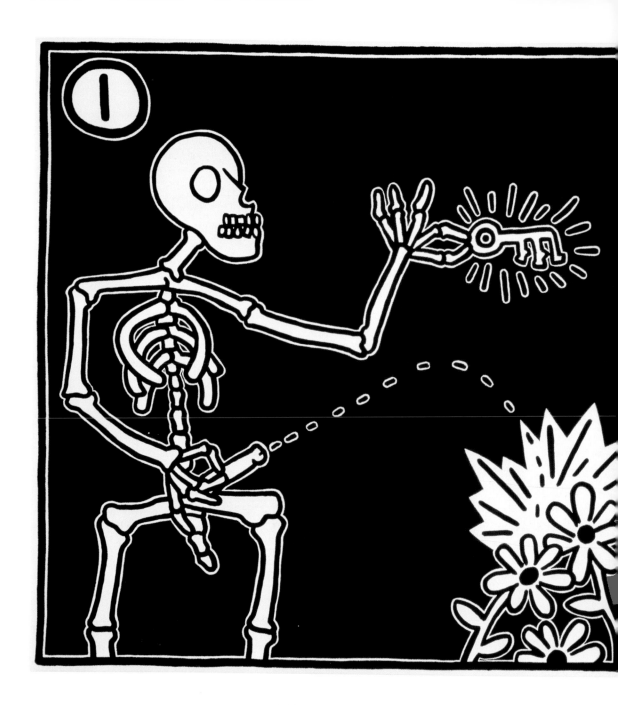

Untitled (for James Ensor), 1989
Acrylic on canvas, two parts, each 92 x 92 cm
Courtesy Arario Gallery, Cheonan, South Korea

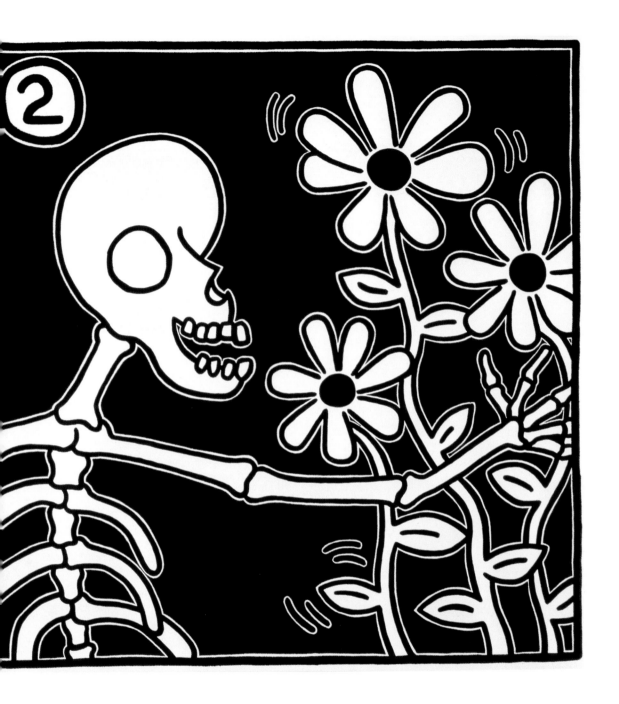

The Finale

In the final years of his life, Haring enriched his art with a further complexity. Because of the profound change in his circumstances, Haring felt an increased need for more demanding content in his work. Together with the writer William S. Burroughs, whom he had met in 1987 and whose works Haring had admired ever since his student days, he executed two projects. Under the title *Apocalypse* he created a portfolio of ten silk-screen prints with an accompanying text by Burroughs, which was published in 1988. The next year he produced a series of 15 etchings that illustrate the chapter *The Valley* in Burroughs' novel *The Western Lands*. His activities continued to be tireless. Haring opened and closed a second *Pop Shop* in Tokyo, executed large open-air sculptures in Düsseldorf and prepared his biennial exhibition at Tony Shafrazi's gallery, which was to be his last. The loss of Andy Warhol, Jean-Michel Basquiat, Juan Dubose and many other close friends, along with his own AIDS diagnosis, meant that this was a time marked by upheavals. Haring used the Shafrazi show to present a résumé of everything he had achieved until then. The formally stretched canvases departed from the usual rectilinear form. His painting surfaces took the form of circles, triangles and occasional squares. As far as content was concerned, a completely new trend became apparent, not seen in his previous works. He experimented with paint applied thickly to unprimed canvas, whereby the paint ran at the edges, leaving parts of the white canvas visible. The traces of these "drippings" were an essential component of the pictures (ill. p. 84). His iconographic messages lose the immediacy of his comic-like figures. The profundity of the pictorial structure also extends to the level of content, and immediate access for the beholder is rendered no easier as a result. In place of the monochrome large-area application of paint, we see rather more of a painterly approach. The juxtaposition of figures and signs has given way to a dense weave.

Walking in the Rain (ill. pp. 88/89), painted on October 24, 1989, documents this experimentation with form and colors. The blue canvas is coated with a dense network of white signs and pictograms. Striding across the whole is a bird-like being, rapidly sketched out in black paint. The resulting drips and the painted drops support the association with rain, to which the title has already alluded. Dated the same day is *The Last Rainforest* (ill. p. 87), which conveys parallels in its manner of execution. Instead of one central figure, the surface of the picture is covered over and over with a texture of mutually entangled mini-scenes. In the

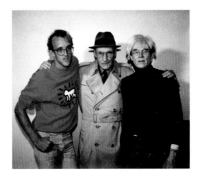

Keith Haring, William S. Burroughs and Andy Warhol, 1985

ILLUSTRATION PAGE 84:
Brazil, 1989
Acrylic and enamel paint on canvas, 183 x 183 cm
Courtesy Per Skarstedt Fine Art, New York

dense jungle, abstruse creatures are born, human beings fall prey to their lust, while the trees resemble pieces of technical apparatus. A diffuse scenario of absurd but always interconnected links between man, beast and nature, which in its entirety offers a thought-provoking image of the rainforest. These pictures stand not only for an artist's incredible creative drive, but also for an inexhaustible mental potential.

In Europe, Haring continued to enjoy great recognition. There, his pictures were collected long before the American market reacted. "What I can't understand is that in 1989 and going into 1990, there's still resistance to my work from the American art establishment—from the American museum world. In a way, I'm glad there's resistance, because it gives me something to fight against. As always, my support network is not made up of museums and curators, but of real people." On the one hand, public recognition by the man on the street was very important to him, while on the other, he suffered as a result of not being acknowledged by the museums. One reason for his sluggish acceptance in his own country was doubtless the unusual course his career had taken. "Well, I really do believe that it will all happen later—the acceptance. It's going to happen when I'm not here to appreciate it." He was to be proved right. It was only after his death that his eminent importance was registered by the art world and his work honored in major exhibitions.

In the summer of 1989 a commission to paint the exterior wall of the Church of Sant'Antonio took him to Pisa in Italy; it was to be his last public work. Haring himself described his sojourn in Pisa as one of the high points of his whole career. Amid great public interest, he painted the mural *Tuttomondo* (ill. p. 90). The large figures and animals, executed in typical Haring fashion, unite the content of every sphere of human activity. This mural was Haring's final hymn to life.

While still alive, Keith Haring set up a foundation which bears his name, and in his will specified that his assistant Julia Gruen should continue to run it as he would have done. According to his wishes, particular support is being given to children's charities and to organizations involved in the fight against AIDS.

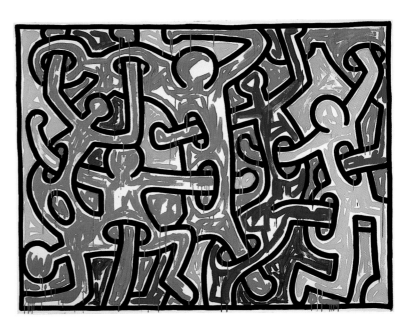

Untitled, 1988
Acrylic on canvas, 183 x 244 cm
Private collection

The artistic goal of the foundation is to use exhibitions and other projects to familiarize a broad public with Keith Haring, the artist and the man.

His last studio picture is dated November 1989, a time when his energy and artistic activity were still intact (ill. p. 91). As a veritable final picture, the untitled painting occupies an important place within his total œuvre in a number of respects. It shows a cheerful scene, seemingly in mockery of all the fears. Difficult for the beholder to make out at first, his typical figures, their arms spread out wide, crowd on to the large-format canvas. The behavior of the cheering figures can be read as an apotheosis. In a gesture of mass worship and glorification, they raise their arms heavenward. The large areas of barely undifferentiated paint enhance this impression, for they make it hard at first sight to differentiate between the figures and the spaces between them. The short brush-strokes, added subsequently in a different color on the contour line, result in drips over the whole surface of the picture, resembling a fine veil which blurs the precise painting beneath. On the painterly level too, this work can be interpreted as a kind of artistic résumé. It unites numerous of Haring's technical experiments. Thus the drawn line, which fills the entire picture, recalls his early works on vinyl tarpaulin, while the pictograms which fill up the space point to his predilection for hieroglyphic symbols, while the trails of paint go back to his "drippings".

The Last Rainforest, 1989
Acrylic on canvas, 183 x 244 cm
New York, David LaChapelle Collection

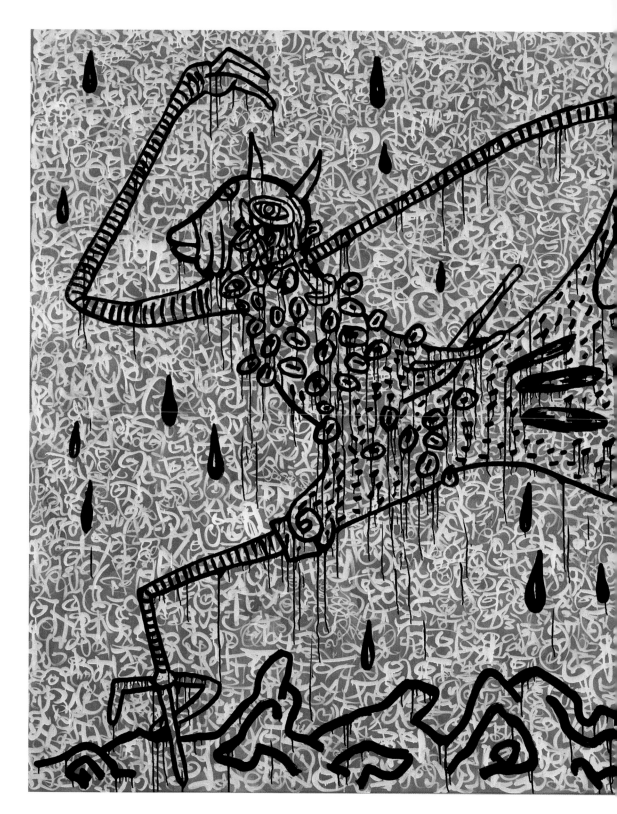

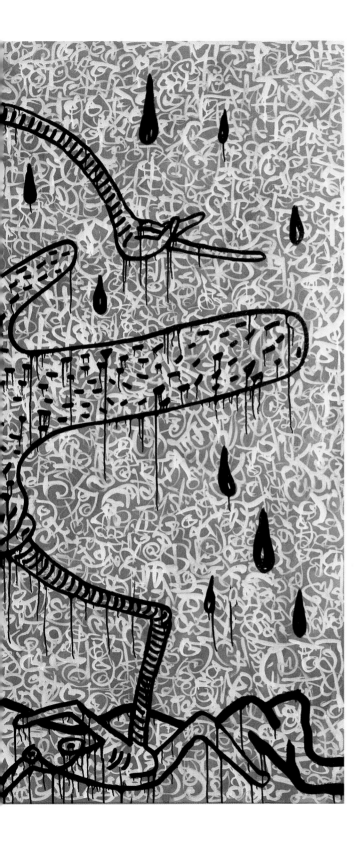

Walking in the Rain, 1989
Acrylic on muslin, 183 x 245 cm
New York, The Estate of Keith Haring

At the end of January 1990, Haring's condition deteriorated visibly. He was already so weak that he could no longer even paint. Shortly before his death he confessed to his biographer: "You can't despair, because if you do, you just give up and you stop. To live with a fatal disease gives you a whole new perspective on life. Not that I needed any threat of death to appreciate life, because I've always appreciated life. I've always believed that you live life as fully and as completely as you can—and you deal with the future as it comes to you."

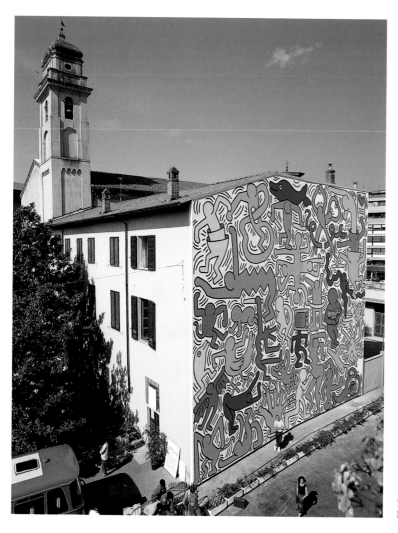

Tuttomondo, 1989
Mural, Church of Sant'Antonio, Pisa, Italy

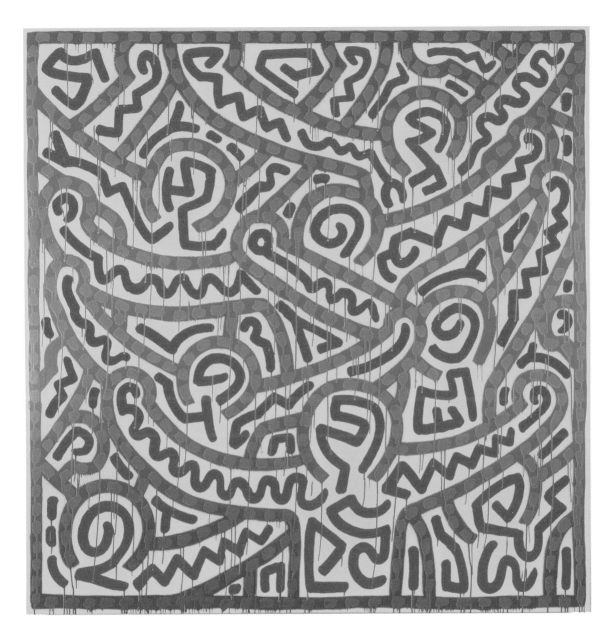

Untitled, 1989
Acrylic and enamel paint on canvas, 183 x 183 cm
New York, The Estate of Keith Haring

Keith Haring 1958–1990
Chronology

1958 Born on May 4 in Reading, Pennsylvania, the eldest of four children, Keith Haring develops a great interest in drawing even as a child. His father Allen supports and encourages this passion. During a visit to the Hirshhorn Museum in Washington D.C., Haring sees for the first time works by Andy Warhol, a Marilyn series. This experience leaves a lasting impression.

1976–1978 After graduating from high school in Kutztown, Pennsylvania, in 1976, he takes his parents' advice and enrolls at the Ivy School of Professional Art, Pittsburgh, Pennsylvania, to study commercial graphic design. After just two semesters, Haring discontinues his studies, in order to devote himself exclusively to art. He continues to attend seminars and uses the university's facilities. Apart from everyday influences, Haring's chief sources of artistic inspiration are the works of artists such as Pierre Alechinsky, Jean Dubuffet, Robert Henri and Christo. Under their influence, his graphic style develops under the primacy of the line.

1978 Aged just 19, Keith Haring has the opportunity of a solo exhibition at the Pittsburgh Arts & Crafts Center. For all his excitement at getting such a chance so early, he realizes that Pittsburgh offers few opportunities for his further artistic development. The same year he decides to leave. Haring moves to New York and enrolls at the School of Visual Arts (SVA). As a student he develops videos, installations and "cut-ups" based on the *Truisms*

of Jenny Holzer and the techniques of William S. Burroughs and Brion Gysin. At an early stage, he seeks contact with the public by presenting his works on the streets and in clubs, where everyone can see them. Haring is of the opinion that art should be accessible to all, and not just an exclusive elite. He makes friends with artists such as Kenny Scharf and Jean-Michel Basquiat as well as with musicians and actors. As time goes by, he becomes a fixture on the alternative art and club scene.

1980 With his sure sense of timing, Haring becomes aware of the spaces left by expired advertising posters in the New York subway stations, which he covers with his chalk subway drawings (ill. pp. 18–23, 93 top). These surfaces prove to be an ideal opportunity to communicate with a mass public and to share his art with others. Soon, the subway is to become, in Haring's

ILLUSTRATION LEFT:
Keith Haring in action in 1984. He executed his works directly on to the wall, without preliminary sketches.

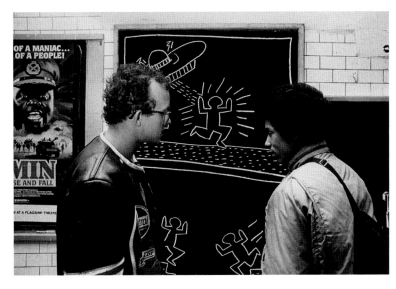

own expression, his "laboratory", in which he can carry out his experiments with his clear lines. It is here too that he presents his "radiant baby" (ill. p. 8 top) for the first time, a crawling baby surrounded by a garland or halo of rays. At the same time, Haring takes part in a group exhibition, the Times Square Show, which allows him to display his work in a context where it can be directly compared with that of other artists. In the fall of 1980, he decides not to enroll for the winter semester at SVA. He leaves the school without earning a degree; it will be bestowed posthumously in 2000.

1981 Haring organizes numerous group exhibitions at Club 57 and the Mudd Club. His own exhibitions at the Westbeth Painters Space, Club 57, the Hal Bromm Gallery and P. S. 122, are designed as space-consuming large-scale installations. These latter were the subject of the first review of his work in the *SoHo Weekly News*. At this time he is already starting to make a profit from the sales of his works. He meets Juan Dubose, who becomes his steady partner.

1982 The gallery-owner Tony Shafrazi agrees to an ongoing arrangement to exhibit Haring's works. The paintings in his first solo exhibition are predominantly executed on vinyl tarpaulins. This industrially produced protective material is inexpensive to buy and allows him also to paint large-format pictures. The paintings and drawings in the exhibition continue the style of his subway drawings. A further event which increases his popularity is a 30-second animation of his various icons, which is shown every 20 minutes for a month on the Spectacolor Billboard in New York's Times Square (ill. p. 32 bottom). Through his contacts with the graffiti scene, Haring's attention is drawn to LA II, a young graffiti artist with whom he executes a number of joint projects. At the same time, his works start to become known in Europe. In the fall, he takes part in the seventh annual *documenta* exhibition of contemporary art in the German city of Kassel. This is followed by trips to the Netherlands, Belgium and Japan.

1983 Haring travels to Italy for the first time and exhibits his works in the

Galleria Lucio Amelio in Naples. He meets the writer William S. Burroughs, whose work he has greatly admired since his student days. He takes part in the Whitney Biennial in New York and also in the São Paulo Biennale. On the occasion of the opening of his exhibition at the Fun Gallery, he happens to meet Andy Warhol. A friendship develops between the two artists, characterized by mutual respect and an exchange of ideas about art. Haring executes his first body painting: the body in question is that of the choreographer Bill T. Jones.

1984 A large proportion of his public works is created in connection with charitable projects for the benefit of children. He gives drawing workshops in schools and museums in New York, Amsterdam, London, Tokyo, and Bordeaux, and designs motifs for literacy campaigns in the United States and Germany. He paints a mural for the Walker Art Center in Minneapolis, followed by others in Sydney, Melbourne and Rio de Janeiro. As he is regularly surrounded by children and teenagers when painting in public, he always has stickers and buttons with him, which he can distribute to his young fans. He executes a second body painting, this time on the body of Grace Jones (ill. p. 55). In the summer he is invited to take part in the Venice Biennale. He designs the stage set for a production of *The Marriage of Heaven and Hell* (ill. pp. 62/63) by the Ballet National de Marseille.

1985 For the first time, Haring presents his steel and aluminum sculptures at the Leo Castelli Gallery in New York. For a first major solo exhibition at the Musée d'Art Contemporain in Bordeaux, he paints the cycle *The Ten Commandments* on enormous canvases. Haring steps up his political commitment and becomes a public opponent of apartheid in South Africa. AIDS becomes a further important theme, which Haring confronts in his art in numerous ways. At the Paradise Garage he meets his new lover Juan Rivera, separating from his long-time partner Juan Dubose.

1986 In April 1986, Haring opens his first *Pop Shop* in New York's SoHo (ill. p. 46), which sells his products, such as T-shirts, posters, stickers and magnets. Conceived as an extension of his work, the *Pop Shop* is intended to allow people to share in Haring's art. Closeness

to the people on the streets continues to be one of Haring's main priorities. By this time, he has already created more than 50 works in public places around the world, many of them with social messages. Some mural paintings are in prominent places such as hospitals and churches; others, by contrast, in less obvious sites.

1987 Haring is given solo exhibitions in Helsinki, Antwerp and the resort of Knokke on the Belgian coast. For the Luna Luna amusement park in Hamburg, he designs a carousel, as a result of which he meets Niki de Saint-Phalle and Jean Tinguely. In addition, in Germany he takes part in the "Sculpture Projects in Münster" exhibition, with his work *Red Dog for Landois*.

1988 When he discovers that he is infected with HIV, many of his pictures take on a new acerbity and abrasive-

ness. His personal condition, teetering between hope and hopelessness, does not, however, stifle his artistic energy, but, on the contrary, makes it all the stronger. Haring works indefatigably, as though he were seeking to vanquish his own destiny through painting. His commitment to the anti-AIDS cause grows stronger. A branch of *Pop Shop* opens in Tokyo.

1988–1989 During the final year of his life, Haring enriches his art with a new kind of complexity. He embarks on an artistic collaboration with the writer William S. Burroughs, creating illustrations for two works (*Apocalypse* and *The Valley*). In addition, he executes large murals in Barcelona, Monaco, Chicago, New York, Iowa City and Pisa. In the city of the Leaning Tower, he paints the exterior facade of the Church of Sant'Antonio with his mural, *Tuttomondo* (ill. p. 90): he describes this as one of the highlights

of his career. On the private level, he spends a great deal of time with his friend Gil Vazquez, who becomes his last platonic partner. Before his death, Haring sets up a foundation that bears his name; he appoints his assistant Julia Gruen to run it. The purpose of the foundation is to support children's charities as well as to fund organizations dedicated to fighting AIDS. In addition, the foundation devotes itself to the cause of bringing Keith Haring the man and the artist to the attention of a broad public through exhibitions, publications and the loan of pictures (www.haring.com and www.haring-kids.com).

1990 On February 16, 1990 Haring dies of AIDS, at the age of just 31.

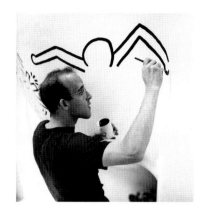

ILLUSTRATION PAGE 94:
Keith Haring on one of his steel sculptures in a foundry in Düsseldorf, ca. 1987.
Courtesy Galerie Hans Mayer, Düsseldorf, Germany

ILLUSTRATION TOP:
Keith Haring at work in the Dragon House in Knokke, Belgium, 1989

ILLUSTRATION RIGHT:
Keith Haring painting a miniature car at Le Mans, 1984
Courtesy Galerie Jérôme de Noirmont, Paris

Bibliography

Drenger, Daniel: Interview with Keith Haring, in: *Columbia Art Review*, Spring, 1988.

Gruen, John: *Keith Haring: The Authorized Biography*. New York, 1991 (Simon & Schuster, New York).

Keith Haring, Journals. Preface by David Hockney. Introduction by Robert Farris Thompson. New York, 1996 (Viking-Penguin, New York).

Keith Haring. Foreword by David A. Ross. Essays by Elisabeth Sussman, David Frankel, Jeffrey Deitch, Ann Magnuson, Robert Farris

Thompson, Robert Pincus Witten. Exhibition catalogue, New York, Whitney Museum of American Art, 1997 (Whitney Museum of American Art, New York and Little, Brown & Co., Boston, MA).

Keith Haring. Essays by Wolfgang Becker, Gianni Mercurio, Enrico Pedrini, Jérôme de Noirmont, Alexandra Kolossa. Exhibition catalogue, Aachen, Germany, Ludwig Forum für Internationale Kunst, 2000 (Electa, Milan, Italy).

Keith Haring: The SVA Years 1978–1980. Essays by Janet B. Rossbach, Jeanne Siegel, Kenny Scharf, Barbara Schwartz, Lucio Pozzi, Bill

Beckley, Gonzalo Fuenmayor. Exhibition catalogue, New York, School of Visual Arts, 2000 (School of Visual Arts, New York).

Keith Haring—Heaven and Hell. Essays by Götz Adriani, Ralph Melcher, David Galloway, Andreas Schalhorn, Giorgio Verzotti, Ulrike Gehring. Exhibition catalogue, Karlsruhe, Germany, Museum für Neue Kunst/ZKM, 2001 (Cantz, Stuttgart, Germany).

Rubell, Jason: Interview with Keith Haring, in: *Arts Magazine*, September, 1990.

Photo Credits